SCHIELE

Christopher Short

Phaidon Press Limited
Regent's Wharf
All Saints Street
London N1 9PA

First published 1997
© Phaidon Press Limited 1997

A CIP catalogue record for this book is obtainable from the British Library

ISBN 0 7148 3393 2

Printed in Hong Kong

Cover illustrations:
Front: *Fighter* (1913). Pencil and gouache on paper, 48.8 x 32.2 cm. Private collection
Back: *Cardinal and Nun (Caress)* (Plate 25)

Acknowledgements: AKG London/Erich Lessing: Figs. 18, 34; Plates 16, 17, 19, 22, 34, 42; Graphische Sammlung Albertina, Vienna: Figs. 10, 27; Plates 8, 9, 14, 23, 24, 31, 36; Bridgeman Art Library: Figs. 14, 19, 16; Plate 43; Öffentliche Kunstsammlung Basel, Kunstmuseum/Martin Bühler: Fig. 29; Christie's Images, London: Plate 1; Neue Galerie am Landesmuseum Joanneum, Graz: Plate 2; Courtesy Galerie St Etienne, New York: Plate 27 private collection [Kallir P262], Plate 48 private collection [Kallir D2496], Fig. 2 private collection [Kallir D151], Fig. 5 private collection, Fig. 30 private collection [Kallir D1995]; David Heald/The Solomon R. Guggenheim Foundation, New York: Plate 41; Historisches Museum der Stadt Wien: Plate 30; The Israel Museum, Jerusalem: Fig. 24; Leopold Museum, Privatstiftung, Vienna: Figs. 3, 13, 31; Plates 7, 12, 13, 18, 21, 25; Neue Galerie der Stadt, Linz: Plate 28; The Minneapolis Institute of Arts: Plate 45; The Museum of Modern Art, New York: Plate 5; Österreichische Galerie Belvedere, Vienna: Fig. 6; Plates 44, 47; Staatsgalerie Stuttgart: Fig. 21; Fundación Colección Thyssen-Bornemisza, Madrid: Plate 32

Schiele

The Austrian artist Egon Schiele, who died in 1918 at the age of 28, was one of the most important artists of the early twentieth century, and an important figure in the development of Expressionism. His paintings and drawings have a direct and powerful impact, and the expression of feeling in them is so intense that they speak to us of our own, as well as of the artist's, experience. Yet to appreciate them fully we need to move beyond these seemingly timeless qualities, and to attempt to enter the world in which they were created.

Schiele (Fig. 1) was born on 12 June 1890 in the town of Tulln, which was part of the Austro-Hungarian Empire. By the turn of the century, the Empire, and imperial Vienna in particular, had become prosperous and technologically developed. Industrial capitalism had created a rising, economically powerful bourgeoisie which became the driving force of not only the Empire's economy, but also of its moral and cultural values. As the benefits of wealth and technology brought to ever greater numbers a life of relative leisure, and indeed the belief that such improvement would continue inexorably, bourgeois life became more comfortable, more tidy, and healthier. Science was acclaimed as the driving mechanism behind this 'progress'.

But society was far less stable than this would suggest. As Vienna became the fourth largest city in Europe, the divisions between rich and poor became more pronounced; the city's slums became among the worst in Europe, undermining the progress so obviously manifest in the bourgeois quarters. Equally unstable was the outwardly strict moral rectitude which prevailed in cities throughout Europe at the time. Sexuality, considered both disruptive and dangerous, was driven from public view. Yet at the same time, it was the men (fathers and sons alike) of precisely that class which most fervently championed such morality who indulged, as a matter of course, in the services of the innumerable professional women available to them in the city. Women were either the daughters of such men, to be protected from exposure to anything of questionable morality, or a low-class commodity for carnal gratification.

By the beginning of the twentieth century, artists and intellectuals had begun to expose the unsavoury truths which the ruling classes sought to keep hidden from public view. Indeed, it is precisely the contradictions between personal and social values and practices that are crucial to our understanding of key moments in the art and life of Schiele.

Egon was the third child of the Tulln station master Adolf Schiele and his wife Marie; his older sisters were Elvira, who died in 1893 at the age of ten, and Melanie, who was born four years before Egon. Gertrude, his younger sister who later figured regularly in his work, was born in 1894. He was initially raised and educated in Tulln, about 20 miles from Vienna in Lower Austria; then he went briefly to secondary school in Krems. From 1902, he attended the secondary school at Klosterneuburg.

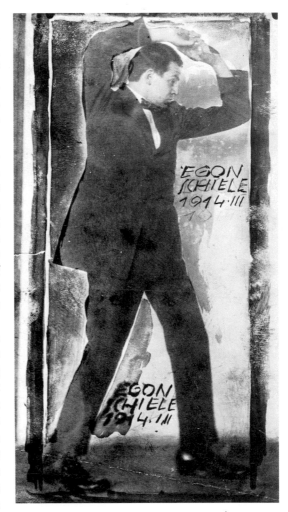

Fig. 1
Egon Schiele Full Length with Raised Arms
1914. Photo by Anton Trcka, altered by Schiele

As a civil servant of the Empire, and a member of its petit-bourgeois class, Adolf was guaranteed a secure future, and should have been able to provide a comfortable living for his family. At their marriage, Marie was only 17 years of age and, innocent of mind and body, was horrified at the prospect of consummating the affair. Adolf, on the other hand, was far from innocent; he secretly brought to the nuptial chamber a recently contracted case of syphilis. Refusing to admit to himself that he had the disease, treatment was out of the question, and in 1902 the illness is thought to have entered its final, terminal phase. His mind rapidly deteriorated, giving rise to sometimes bizarre behaviour: frequently, Adolf would bring to the family home for dinner various imaginary officials and dignitaries from the railway. The family, it seems, learnt to humour such aberrations, though there can be little doubt that it was a stressful and disorienting time for the children. Egon had, for some time, been committed to the idea of becoming an artist, and spent much of his time (too much, to his father's mind) drawing. In particular, it seems, he was interested in depicting trains, and from the works that remain, it is clear he was quite good at it. At school he neglected academic studies, gaining 'unsatisfactory' in all subjects except drawing, calligraphy and gymnastics. Spurned by most of his teachers in Klosterneuburg, he at least had the support of the art master, Ludwig Karl Strauch, who gave him particular encouragement. Not only did he introduce Egon to a range of skills in school, but he invited him to come to his own private studio to work alongside him.

Adolf Schiele died in 1905. Apparently, in a fit of insanity, he had burned his railway shares, leaving the family less able to afford the middle-class lifestyle to which they had become accustomed. The task of securing a steady income now fell to Melanie, while Egon's uncle, Leopold Czihaczek (Plate 1), became his guardian. Egon had little in common with his uncle, who poured scorn upon his artistic ambitions. At the same time, his relationship with his mother gradually became more distant, partly because he felt she did not share the sadness he felt at the memory of his 'noble' father. In school, he made few friends, preferring instead the company of his sister Gerti. The potentially erotic connotation of his relationship with her has been the object of much speculation among Schiele scholars, as it was in the family itself; one time, fearing the worst, their father had broken down a locked door behind which Egon and Gerti were in darkness developing a photographic film; another time, and much more extraordinarily, the 16-year-old Egon took his sister (then only 12) to Trieste, where they took a double room in a hotel; he chose the place because it was here that their parents had spent their honeymoon.

In 1906, as it became clear that Egon would not fulfil his family's wish that he become an engineer, Strauch encouraged his mother to take Egon from school early in order to attend art school. This she did, contrary to the advice of Czihaczek who, in a final attempt to obstruct the move, refused to pay tuition fees. Taking his folder to the School of Applied Arts in Vienna, Egon was advised by the professors, highly impressed by the extraordinary quality of his work, to go straight to the more prestigious Academy of Fine Arts. In the autumn of that year, Schiele began to study in the Academy which, a few months earlier, had refused entry to another young hopeful, the future Adolf Hitler.

Soon after being accepted by the Academy, Egon moved to Vienna with his mother and sisters. Each day he would take his midday meal with the Czihaczeks. In spite of his objections, Leopold took his role as guardian seriously, and gave the young student pocket money and paid for his art equipment. Judging by the number of drawings and paintings of the man (no fewer than eight executed in oil), it seems he

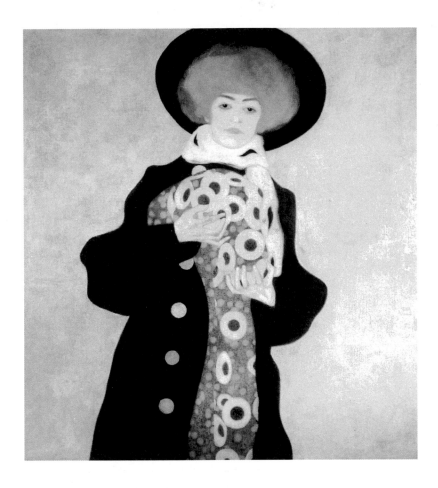

Fig. 2
2 Woman with a
Black Hat
(Gertrude Schiele)
1909. Oil and metallic
paint on canvas,
100 x 99.8 cm.
George Waechter
Memorial Foundation,
Switzerland

was also quite happy to sit for his nephew. Throughout this period, Egon nurtured his Bohemian image and developed an arrogance which must have infuriated those who lived and worked with him. Tension developed between Egon and his master in the Academy, Christian Griepenkerl, a strict disciplinarian who once shouted at him: 'You! You! The Devil shat you into my class!' At first, Egon had been happy to follow arduously the academic exercises which the curriculum demanded of its students. Copying from casts, anatomy, perspective, colour chemistry and colour theory were accepted as the very basis of the European academic tradition. At the slightest sign of dissent or originality, Griepenkerl, sensing an attack by the younger generation on the traditional art for which he stood, would launch the most vicious verbal assaults on his students. He declared to Richard Gerstl, whom he had also recently taught, 'The way you paint, I can piss in the snow.'

While Schiele's technical competence increased greatly during his time at the Academy, the most radical influence on his work came from outside. Already in 1907 he had begun to rent his own studio in the city, and in the same year he began to move in the circle of Gustav Klimt, leader of the Vienna Secession, still regarded by the Academy as a radical and dangerous group. The spearhead of Viennese modernism, the Secession was founded in 1897 in opposition to the Academy and the now academic Artists' House Association, the Vienna Association of Visual Artists. It sought to create an independent forum for artists and craftspeople whose work broke with convention. Within a year, the Secession had obtained its own building, designed by the architect Joseph Maria Olbrecht in what was easily recognizable as the Secession style, and in March 1898 held its first exhibition.

In 1897 Klimt had undertaken to produce three large canvases for the University of Vienna, each to represent one of the departments of philosophy, medicine and jurisprudence. Klimt's works caused a scandal and were rejected by the authorities; not only was the style

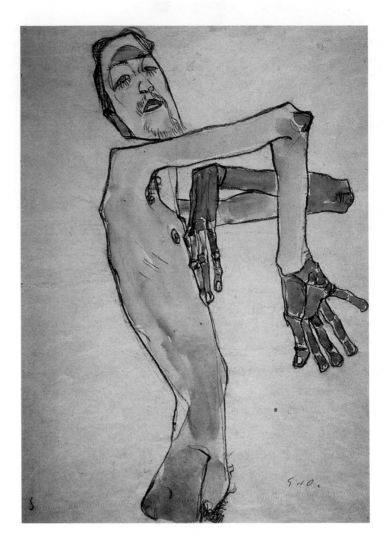

unconventional, but the artist exposed female flesh, together with pubic hair, in a manner considered overly erotic and void of traditional historical and allegorical reference. Schiele himself was later to suffer still greater humiliation for his treatment of similar themes.

Traces of the Secession style, and the influence of Klimt in particular, can readily be found in some of Schiele's works from 1907. This is most obvious in *Water Sprites I*, of 1907 (private collection), which relates directly to the older artist's *Beethoven Frieze* of 1902 (Österreichische Galerie, Vienna). At the Kunstschau, an international exhibition organized in 1908 by Klimt and his circle, Schiele saw no fewer than 16 of Klimt's most recent works, and to some of these he would pay homage: his *Danaë* (1909, Plate 4) is clearly derived from Klimt's work of the same name (Fig. 14). It is not surprising that Schiele's work betrays a profound interest in Klimt, for the older artist, recognizing a powerful creative talent, took a personal interest in his professional progress, sometimes buying or exchanging works with him or introducing him to wealthy patrons. In 1908 he introduced Schiele to the Wiener Werkstätte (Vienna Workshop), an association of designers and craftspeople sympathetic to Secession ideas; the introduction led to Schiele undertaking several commissions for the Werkstätte.

Following the impact of the 1908 show, Klimt arranged a second Kunstschau in 1909, to which he invited Schiele to contribute. Here Schiele showed four works, three of which were portraits: one of Hans Massmann, a classmate from the Academy, one of his future brother-in-law, Anton Peschka (Plate 3), and one of his sister, Gerti (Fig. 2). Significantly, the decorative background of this last portrait was

painted out, signalling a move away from Klimt's decorative style so evident in the others. A prestigious international affair, the second Kunstschau set Schiele's works next to those of his mentor, Gustav Klimt, as well as those of other key members of the European avant-garde including Edvard Munch (1863–1944), Henri Matisse (1869–1954), Vincent Van Gogh (1853–90) and Paul Gauguin (1848–1903).

On 17 June 1909, Schiele and a number of his classmates, including Anton Peschka and Hans Massmann, left the Academy to form their own group, the Neukunstgruppe (New Art Group). The group's first exhibition was held at Gustav Pisko's Gallery in December of that year. Here Schiele met Arthur Roessler, writer and art critic of the Viennese Social Democratic Party newspaper, the *Arbeiter Zeitung*, and soon to be collector and champion of the young artist, as well as the collectors Carl Reininghaus and Oskar Reichel. Between 1912 and 1923, Roessler would publish a total of five books about Schiele, not to mention innumerable articles and reminiscences.

Until 1910, it is clear that Schiele was experimenting with various styles of representation without committing himself to any one in particular. About this time, however, his style changed rapidly, as can be seen if we compare some of the six portraits he was to produce of the original members of the Neukunstgruppe during the course of 1909 and 1910. The portraits of Anton Peschka and Hans Massmann, shown at the international Kunstschau, are close to the Secession style. But the final portrait of this group, that of the mime Van Osen (Fig. 3), painted in 1910, is radically different. What had happened to necessitate such change?

By 1909, Klimt's influence, both stylistic and iconographic, had diminished. The change is particularly evident in Schiele's *Self-Portrait* of that year (Fig. 4), in which he emerges from his Secession-style robe as from a chrysalis. Once this metamorphosis has taken place, other influences come to the fore. Schiele was clearly aware of the work of Munch, Van Gogh, Pablo Picasso (1881–1973) and other members of the European avant-garde, as well as folk and non-Western art forms. However, of more immediate importance was an artist whom Klimt had championed, one-time student at Vienna's School of Applied Arts, and future competitor for the leadership of Vienna's avant-garde, Oskar Kokoschka (1886–1980). Contributing a number of works to both the 1908 and the 1909 Kunstschau exhibitions, Kokoschka developed the sinuous lines of Art Nouveau into an expressive language, which would soon be taken up by Schiele. The illustrations he made between 1906 and 1908 for the Wiener Werkstätte edition of the adult fairy tale *The Dreaming Youths* (Fig. 5), which he dedicated to Klimt, are particularly revealing. The style of some of the figures, similar to that of his other drawings of about this time, clearly prefigures the life drawings Schiele was producing by 1910. Differing radically from the refined works of Klimt, Kokoschka's art (in all its forms) sought to reach beyond the mere appearance or decorative quality of things to show their psychological significance. To do this, form was manipulated and distorted.

Another contributor to Schiele's stylistic development was the artist Max Oppenheimer (1895–1954), whom Schiele first met early in 1909. For many months the two artists worked and talked together, frequently painting the same motifs in somewhat different manners, including portraits of each other (Plate 9 and Fig. 18). Like Schiele, Oppenheimer sought to lay bare the inner, psychological aspect of his subject. Schiele was also influenced by the work of the Belgian artist Georges Minne (1866–1941), which was exhibited at the second

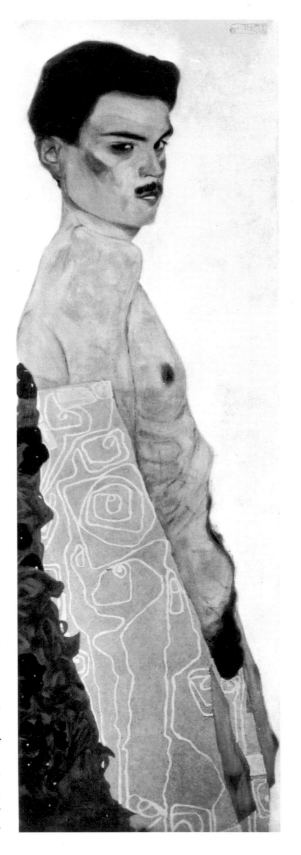

Fig. 4
Nude Self-Portrait with Ornamental Drapery
1909. Oil and metallic paint on canvas, 110 x 35.5 cm.
Private collection

Kunstschau, and had in fact been shown in Vienna as early as 1900. Particularly important were his kneeling boys (Fig. 6), to which Schiele later referred, attributing to Minne's work his preference for fleshless 'Gothic' youths, and articulating this preference in opposition to the excessively ornamented style of certain Werkstätte products, which he had come to reject as irrelevant. Like Kokoschka, Schiele took from Minne's works the themes of mourning, death and pain, as well as his emphasis on the bodily expression of suffering, pathos and 'inner' states of consciousness.

This brings us to a point that is fundamental to our understanding of what had begun to happen in the 1910 portrait of Van Osen. Why should the artist turn so radically from the elegant beauty of his Klimt-like images to the extraordinary excess, even ugliness, of the Van Osen portrait?

The idea that art could somehow represent more than the appearance of things is an ancient one. Plato, for instance, as early as the fourth century BC, asserted that the artist should represent the 'workings of the soul' through accurate representation of the way 'feelings affect the body in action'; by the nineteenth century, philosophers, particularly in the German-speaking world, had come to articulate a strikingly similar task for the arts. At the end of the nineteenth century, artists opposed to the constraints of academic painting sought, through manipulation of colour, line and form, to articulate their 'inner' response to things. This gave rise, among other forms, to what has been called Expressionism, a term commonly used to describe the most important of Schiele's work, in which he sought to articulate his psychic world, and lay bare that of the people he represented. In the portrait of Van Osen, he distorts form and colour as normally perceived in order to achieve this end.

For Schiele, for an extended period from 1910, the encounter with

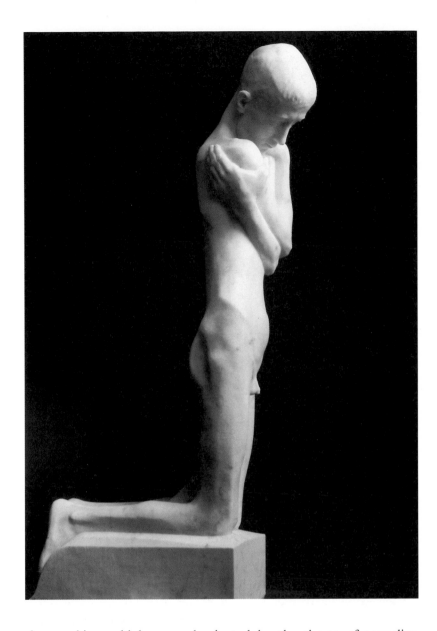

the psychic world became dominated by the theme of sexuality. This development is most visible in a series of three large nude self-portraits and two portraits of his sister, Gerti, produced during 1910. In 1909, Schiele had painted his sister (Plate 5) in a manner still reminiscent of Klimt. The whole is quite elegant, perhaps beautiful. The 1910 painting (Fig. 7) stands in stark contrast. Gone are the elegant forms, patterns and colours, and in their place stands the emaciated, unprotected body of the artist's younger sister. His own body was subject to similar treatment. The three portraits, *Self-Portrait Kneeling with Raised Hands*, *Self-Portrait Standing with Hands on Hips* (present locations unknown), and *Seated Male Nude (Self-Portrait)* (Plate 7), seek to expose not only the artist's awkwardly distorted body, but the anguished, questioning self which is an integral part of that body; in the self-portraits, though, there is also a degree of exhibitionism, a proclamation of the self as sexual subject, and a certain narcissistic self-absorption.

Schiele's own body and especially his state of mind now become a central theme in his *œuvre*. Why should he turn to himself, and to his sexual relationships with others, in this way? In addressing this question, there is a social as well as a personal dimension. At the turn of the century, the arts in Vienna had begun to articulate the decay which lay behind the city's glorious economic and social façade. In so doing,

11

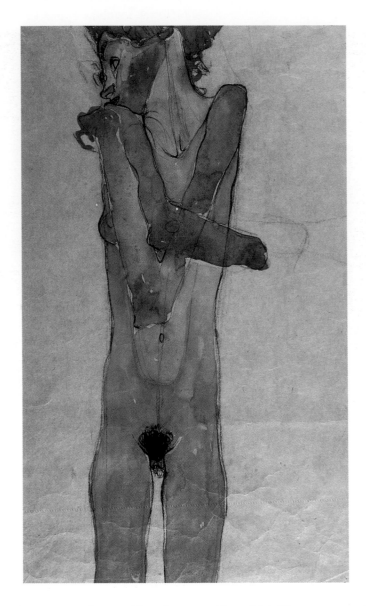

Fig. 7
Nude Girl with
Folded Arms
(Gertrude Schiele)
1910. Watercolour and
black crayon on paper,
48.8 x 28 cm.
Graphische Sammlung
Albertina, Vienna

they began to make manifest that sexuality which Viennese morality drove from the public arena. But more significantly, sexuality was explored on the analyst's couch, in the work of the founding father of psychoanalysis, the Viennese Sigmund Freud, who produced a systematic account of the unconscious, uncovering the importance of sexual drives. He asserted that the libido (as he called the sexual drive) was fundamental to all people, and if repressed, or driven away from the surface and hidden in the depths of the psyche, would reappear elsewhere as some form of psychic disorder. Rather than repress such urges, as contemporary morality did, the arts would sublimate this libido: that is, they would convert it into an artistic impulse rather than allow it to be hidden. But in the work of certain artists – among whom we would name Schiele – who recognized, independently of Freud, the need not to repress such urges, the libido was sometimes scarcely 'sublimated' at all as the work became an arena in which artists dealt directly with issues of sexuality – sometimes with disastrous consequences.

At the time of the execution of works such as *Seated Male Nude (Self-Portrait)*, Schiele was only 20 years old and, having grown up and passed through adolescence in a repressive society, was attempting to establish his own sexual identity. In making manifest his sexuality, he failed to conform to society's strict social rules and mores, and developing a sense of alienation from the social, retreated into the

Fig. 8
Self-Seers I
1910. Oil on canvas,
80 x 79.7 cm.
Private collection

personal. This move proved traumatic, for in escaping the conventional structures society created for sexual identity, the artist's own explorations uncovered a series of disorienting instabilities and confusions within the self.

This anguished preoccupation with sexual identity can be seen in the unmistakable similarity in form between the torso in *Self-Portrait, Nude* (Plate 12), and an erect, vascular penis. The extended stomach region is decidedly shaft-like, the bottom of the ribcage reminiscent of the base of the sensitive glans, the ribcage and head representing the glans itself. The same formula would be repeated in several self-portraits of the same year. Schiele's identity is given over to that of his sexual organ, to the sensations it manifests, a theme that is explicitly represented in *Self-Portrait in Black Cloak, Masturbating* (Plate 14). The subject of masturbation was very much taboo in turn-of-the-century Vienna, and public displays of auto-eroticism were surely not the norm. It is interesting to see this painting in the light of what Freud called the 'castration complex', in which the infant boy, on seeing the absence of his most prized possession on a female, takes fright at the possibility that he could be separated from his organ following parental threats (particularly from his father) as a result of his too intense interest in it. The act of masturbation, then, is accompanied by a sense of guilt and concomitant fear. In *Self-Portrait, Nude* and related works, the threat of castration is represented symbolically in dismembered forms, specifically the exclusion of the arms whose digits perform the act itself.

In the works of 1910 we are confronted for the first time with certain hermaphrodite tendencies. In *Seated Male Nude (Self-Portrait)*, the artist suggests the presence of breasts with, for the male body, oversized nipples. In other works this identity with the other sex extends to the feminizing of facial features and the exclusion of the penis. A striking example, produced in December 1910, after the initial nude self-portraits but before those representing auto-eroticism, is *Self-Seers I* (Fig. 8), the first of the three allegorical double

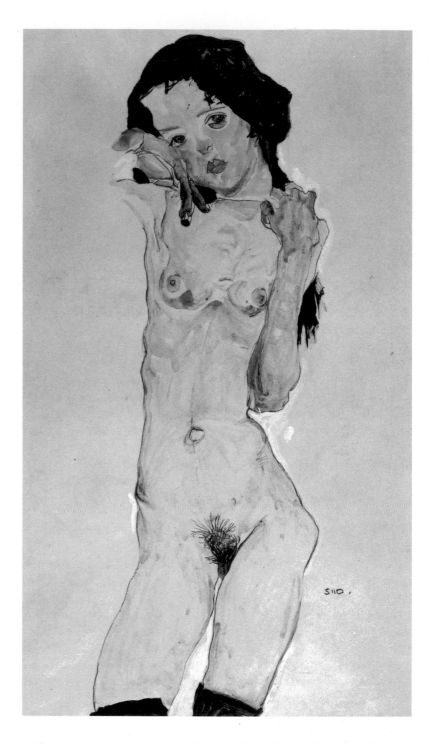

self-portraits developing the theme of the *Doppelgänger* which had been of great interest to the German Romantics throughout the nineteenth century and had come, by the beginning of the twentieth, to be significant as a projection of the unconscious, a manifestation of the self divided along a number of axes. In *Self-Seers I*, that division occurs most obviously along the gender axis, with the masculine features on the face of the figure in front contrasting with the softer, more feminine ones behind, and pectoral muscles clearly visible on the chest of the former compared with the breast-like outline of the chest behind. Yet the penis is conspicuously absent from the figure in front. The gender axis for Schiele is no simple affair. *Prophets (Double Self-Portrait)* (Fig. 21) recalls a familiar nineteenth-century format for the self-portrait in which death in the form of a skeleton appears over the artist's shoulder. In the third painting, *Self Seers II (Death and Man)* (Plate 13), this theme is extended so that the artist is caught in an

embrace with the death which forms part of his life; where one form begins and the other ends is unclear as the artist recalls his proclamation that 'Everything is living death.'

The female nude, a genre Schiele would develop in various forms, many of which would serve as objects for his own sexual interests, was one which he maintained throughout his *œuvre*. Most convenient of these, in that they served the immediate, practical necessity of providing an income, were the erotic (or pornographic) works. During the winter of 1910 the artist was confined to Vienna and, retiring from social relations, began to retreat into his own private world and simultaneously to indulge his fascination with the female form. Frequently the object of his paintings were the children of working-class families who, often hungry and in poor health, would come to the artist's studio as an escape from their everyday lives, there to be drawn by the artist who offered them sanctuary. Of the many studies produced of these children, few could be called remotely erotic. Some, however, clearly were: the focus of interest in works such as *Observed in a Dream* (Plate 15) and *Black Haired Nude Girl, Standing* (Fig. 9) requires little interpretation.

As the artist became increasingly dissatisfied with life in the city he thought seriously of settling permanently in Krumau, his mother's birthplace; he was fond of the old town and, for him, it was a kind of romantic retreat from the metropolis. When he finally moved there in May 1911, he brought with him his new model and mistress, Valerie Neuzil (or Wally, as she was called), whom he had met through Klimt earlier that year. Aged 17, she was to be the subject of many of his paintings, erotic and other, until the artist's marriage to Edith Harms in 1915. While in Krumau, he made a series of paintings of what he called the 'dead city' (Plate 18). Structurally quite complex, works such as *Krumau Town Crescent I* (Fig. 24) emphasize the geometric form of the buildings in a manner reminiscent of the townscapes of Georges Braque (1882–1963) and Picasso.

Developing the 'expressive' manner employed by Van Gogh which he had seen at the Kunstschau of 1909, Schiele animated the image of the solitary flower, in particular the sunflower, to articulate particular moods in the same way he had portraits; by 1911 this method extended to individual trees (usually autumnal, with bare branches and withered leaves), as in *A Tree in Late Autumn* (Plate 21) which, in a rather obvious way, resembles a person joyously (or perhaps angrily) kicking a foot and waving arms in the air. The sheer number of works which can be interpreted in a similar manner, together with the later apparent animism of houses in townscapes, reinforces such a reading. In a letter of 1913 Schiele wrote that he was particularly interested in the 'physical movements of mountains, water, trees and flowers. Everywhere one is reminded of similar movements in the human body, of similar motions of joy and suffering in plants.'

During 1911, the number of erotic drawings and paintings of young girls increased, as did, perhaps in response to the presence of Wally, the number of erotic female nudes. As a result of his supposed Bohemian lifestyle, promiscuity and irreligiosity, the artist, having at first been very happy in Krumau, was soon evicted from his quarters and in August 1911 forced to leave. After a short stay with his mother, he and Wally moved to the town of Neulengbach, about 20 miles west of Vienna. As usual, the artist's finances were poor. Letters to his uncle asking for assistance were ignored; being outside Vienna made the securing of commissions more difficult, and the fact that Schiele now wanted to isolate himself from earlier contacts only made things worse. None the less, he was delighted with his new surroundings. For the first time he

equipped his lodgings with his own furniture, much of it from the family home in Tulln, and he seems to have resolved to make his home in Neulengbach. This sense of having his own home is reflected in *The Artist's Room in Neulengbach* (Plate 17). Clearly inspired by Van Gogh's painting of his room in Arles (Fig. 23), it suggests a similar sense of intimacy, but Schiele's room seems far less *angst*-ridden than Van Gogh's.

As had happened elsewhere, Schiele's studio became a gathering place for youngsters willing to be painted in various states of undress, and the people of Neulengbach were no less distressed by the goings-on at the artist's residence than those of Krumau. This time, however, the outcome was very different. From 13 April to 7 May 1912, Schiele was held in prison on suspicion of kidnapping, rape and public immorality. Following the allegations, the police searched Schiele's house; while the investigating officers found little evidence to suggest 'abnormal' activities, careful interrogation – in the guise of conversation – tricked the artist into showing the officers more overtly erotic works which were not on open display, and these were seized as evidence. By the time the trial took place in early May, the first two charges had been dropped owing to inconsistencies in the evidence; the last remained in the form of exposing minors to pornography. During the trial the judge burned one of Schiele's drawings, and he was fined and sentenced to three days in jail: a lenient punishment compared with the period of up to 20 years to which he could have been sentenced on the initial charges.

Schiele's friends were supportive during this crisis; Reininghaus recommended his lawyer and sought to influence the process of law through his various contacts, Benesch went to visit the artist in jail two days after the arrest, and Wally stayed in contact throughout. Only Roessler, who was away on extended vacation at the time, was not there; he later did his bit in defending the artist's reputation in the various books he wrote, shifting any possible guilt from the artist to the general public, who, he suggested, had made a 'vicious blunder', failing to comprehend the needs of artistic genius. The diary Schiele supposedly wrote during his time in prison (which it seems Roessler fabricated on the artist's behalf), devotes much space to articulating in laboured, almost Biblical tones his utter bewilderment that anyone could suspect he had broken the law, let alone done anyone any harm. Roessler and many scholars since have used the event to nurture the idea of Schiele as a marginalized, misunderstood genius.

Of more immediate importance is the body of work – thirteen watercolours and drawings – Schiele produced while in prison, and the effect that period had on his work after. Faced with the possibility of a long prison sentence, Schiele was subjected to intense emotional pressure, which would more than account for the self-pitying tone of the proclamations he wrote on these works: 'I feel not punished but cleansed'; 'For art and for my loved ones I will gladly persevere.'

He began, we are told, drawing with his own spittle on the walls of his cell. After repeated requests he was allowed some poor-quality paper and drawing materials, which were immediately put to use. Having the opportunity to express some of his emotions and thoughts in artistic form undoubtedly helped Schiele deal with what seemed a desperate situation. He produced a series of three more or less successive sets of images: the first dealt in much detail with the interior space of the prison; the second, more introverted, focused mainly on particular personal effects such as handkerchiefs and stockings, draped across a chair; the third was an important series of highly expressive self-portraits which articulate most fully the sense of despair the artist endured (Plate 24).

Almost destitute when he left prison, Schiele moved to Vienna

where he stayed temporarily with his mother. Despite claims made in letters to Roessler explaining that since the time in jail he could no longer work, it is clear that at the same time he was offering new pictures to other collectors. Indeed, while it seems to have suited the artist to portray himself as the suffering martyr to certain friends and associates, his career was in fact beginning to thrive. He was included in the spring 1913 exhibition at the Vienna Hagenbund, a more recent version of the Secession, which brought new patrons and favourable reviews; he was also invited to exhibit at the Sonderbund exhibition in Cologne, had his work taken up by one of Germany's principal dealers, Hans Golz, and was introduced by Klimt to the wealthy industrialist August Lederer whose son, Erich, became a friend and patron. At the end of 1912 Schiele was invited to visit the Lederer family estate in Hungary to paint Erich (Plate 26), using a room in the family-owned liquor factory as a temporary studio. The work marks a significant change in the artist's manner of representation and, it must have seemed, a change in his fortunes.

In the period following his imprisonment Schiele virtually ceased to draw children, and his drawings of women become less overtly erotic (though the erotic was by no means absent). Generally, his work becomes less obviously autobiographical and immediate, more monumental and aestheticized. One particular stylistic feature, the shattering of the surface into geometric forms, now becomes prominent in many works. It first appears in 1911 in oils on religious themes (for example, *The Hermits* (Plate 22)), and can also be seen in the painting of Krumau discussed above (Fig. 24). The 1913 double portrait of Schiele's patron Heinrich Benesch and his son Otto (Plate 28) develops this technique, yet is less insistent on its application in the background. However, this is unusual, and in Schiele's figure drawings – which, together with watercolours, greatly outnumber his oil paintings – flesh continues to be represented in much the same Klimt-influenced manner as always; only the folds of cloth and clothing are manipulated in the new manner.

This stylistic development, coupled with markedly static composition, creates a new sense of order and stability. Yet in spite of the promising close to 1912, the artist's financial situation had, unlike his manner of representation, become less rather than more stable. By January 1914, his debts had reached 2,500 Kronen, approximately the annual income of a wealthy working-class family. Since Schiele was a predominantly graphic artist, it is perhaps surprising that not until such a crisis could Roessler finally persuade him it was time to exploit the economic potential of the print. In the few months following February 1914 he made eight drypoints, but the results were somewhat unimpressive. By the end of summer the artist had lost interest and decided teaching was a more viable option, obtaining his first student, Heinrich Böhler, through contacts in the Wiener Werkstätte. More than just a wealthy student, Böhler supplied his teacher with materials and models, collected his works and paid a monthly stipend through the war years. His cousin, the painter Hans Böhler, bought works from Schiele, and his friend, Friederike Maria Beer, commissioned a large portrait. Upon receiving the commission, and shortly before a one-man show organized by the dealer Guido Arnot (the poster for which he designed; Plate 30), Schiele was finally able to note in a letter to his mother, 'I have the feeling that I am finally out of my uncertain existence – I want to save a little'.

In this responsible, perhaps more domestic vein, Schiele wrote in a somewhat unfeeling manner on 16 February 1915 to Roessler: 'I intend to marry – favourably, not to Wal[ly].' As a lover and model, Wally

fulfilled the artist's needs; as a wife, she lacked the education and social standing expected of any woman to bear the Schiele name. True to his bourgeois values, he expected the woman he was to marry to be of at least equal standing. It was in the spring of 1914 that Schiele first noticed two young women whose father owned an apartment directly opposite his studio on the Hietzinger Hauptstrasse. From there, Schiele would attract the girls' attention by making gestures and holding large drawings to the window. They were guarded by their mother, and the notes which Schiele wrote remained unanswered. However, through the ever loyal Wally, whom he sent to befriend them, he met the girls without their mother's knowledge, and eventually married the younger sister, Edith Harms. But first, Wally had to be dealt with; Edith insisted that Egon make a clean break with her. The upshot was that his hitherto companion left him never to return, eventually dying in Dalmatia in 1917. The allegorical painting *Death and the Maiden* (Plate 34) has been interpreted by some as a testament to the pain the separation caused. The portrait of Edith (Plate 35), made also in 1915, in contrast, is stable (though her look is far from comfortable), suggesting a certain contentment which would become increasingly important from this time, notably in the works he produced that year on the theme of motherhood (for example, Plate 37).

On 17 June 1915 Egon Schiele was married. His mother was not present, as relations between them had long been difficult, but she met them after the ceremony and would later approve unreservedly of her daughter-in-law. Having thus far managed to avoid the war on grounds of weak health, Schiele was now called up for active service in the army; four days after his marriage, he began his military service in the city of Prague. Edith took a room in a nearby hotel. It was scarcely the honeymoon for which they might have hoped. Conditions for the soldiers were particularly harsh, and Schiele was only able to snatch the briefest of encounters with his wife through the fence which enclosed the makeshift barracks. On 27 June he was posted to Neuhaus in Bohemia for training, and then on 27 July back to Vienna to dig trenches. Here he could sleep at home most nights and was able to produce the 1915 full-length oil portrait of Edith (Plate 35). Throughout, Schiele feared most the prospect of being sent to the front, and hoped that his skills as an artist would enable him to secure a post which would reflect his talents and keep him from the line of fire. However, come spring of 1916 this had still not happened; but on 4 May, he was posted to Mühling, a town about three hours from Vienna, as a clerk in a prison camp for Russian officers. Here duties for the artist were lighter, things apparently more pleasant. Not long after his arrival, Schiele was offered an empty storeroom for use as a studio, and was encouraged to produce portraits of his superiors; this he did, extending the brief to include representations of the Russian prisoners (Plate 38).

In these circumstances, Schiele's artistic output for 1916 was lower than that of any other year of his career; while in Mühling he only painted two oils. One of these was the unusual *Vision of Saint Hubert* (private collection), the other was *Decaying Mill* (Plate 39). However, while still in Vienna, before leaving for Mühling, Schiele made an important portrait of his 72-year-old father-in-law, Johannes Harms (Plate 41), significant not only for the sensitivity with which he portrayed this man in the final year of his life, but for the inclusion of the clearly represented chair and the suggestion of floor space in place of the usual background void. This new awareness of space reflected a concern with the creation of pictorial illusion through three-

Fig. 10
Cover of *Die Aktion*
September 1916.
Graphische Sammlung
Albertina, Vienna

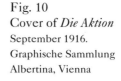

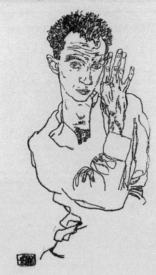

dimensional modelling. Although Harms's body slips from the perspectival chair into the flatness of the picture plane, later works will develop more thoroughly the location of things in the third dimension. This seems to reflect a new-found awareness of the artist's environment, of what exists beyond his immediate world; fewer self-portraits were done, and none were painted.

Schiele's reputation as one of Austria's leading avant-garde artists was boosted by the publication in September 1916 of the 'Egon Schiele Issue' of *Die Aktion*, one of Germany's principal Expressionist periodicals (Fig. 10). In addition to essays on Schiele, it contained five of his drawings, a portrait of him, one of his poems and a self-portrait on the front and back covers – a monument to the artist's achievement which surely paved the way for a significant improvement in fortune. On 12 January 1917 Schiele returned to Vienna to work at the Imperial and Royal Military Supply Depot (Fig. 11). Duties promised to be lighter still, he could sleep at home, and was able to partake of all the supplies (food, drink, tobacco etc.) the depot held.

This heralded a tremendously productive period for the artist. He

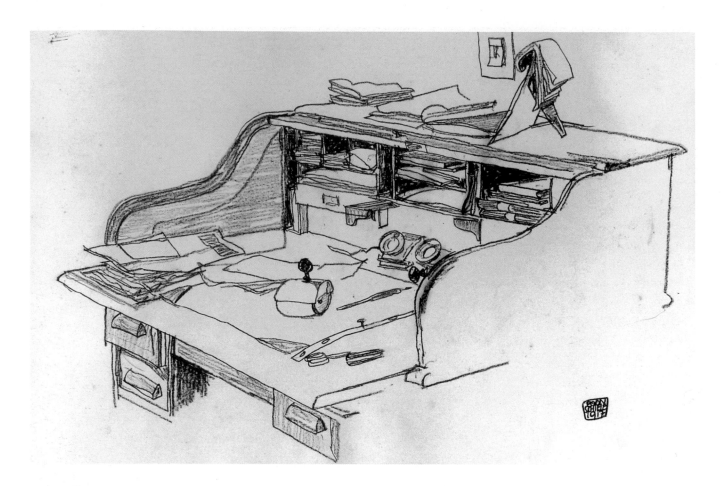

Fig. 11
Karl Grunwald's Desk
in the Office of the
Central Supply Depot
1917. Black chalk on
paper, 29.5 x 46.2 cm.
Private collection

was now a wiser businessman, and his popularity continued to grow. He sold a series of drawings to the Moderne Galerie, a public institution, persuaded the book dealer Richard Lanyi to publish a portfolio of facsimiles of his work, and in May he was asked to arrange the hanging of, and to exhibit at, the Kriegsaustellung (War Exhibition). He showed a piece done in 1913 and renamed it to suit its new function, changing its title from *Resurrection* to *Heroes' Graves – Resurrection: Fragment for a Mausoleum*. He also exhibited some of the prison-camp studies he had made in Mühling. Hoping to revitalize Vienna's cultural community, Schiele made plans to establish an arts centre, 'a spiritual gathering place designed to offer poets, painters, sculptors, architects, and musicians the opportunity to interact with a public that, like them, is prepared to battle against the ever-advancing tides of cultural disintegration.' Despite the support of names such as Klimt, Hoffmann and Arnold Schoenberg, the project never came to fruition; by mid-1917 Schiele had abandoned it.

Nevertheless, in October 1917 Schiele was offered membership of the Secession, and asked to organize its 49th exhibition in March 1918. Schiele's own work was the focal point of the show, occupying the central room with 19 works in oil and 29 on paper. The show, for which Schiele also designed the poster (Plate 46), was a great success, for Schiele sold all available works and secured a number of important commissions. Portrait commissions had already come to dominate his life, and while he continued to produce landscapes and allegorical works, approximately one-third of the paintings he produced in his last two years were portraits. In these works we see the extension of that 'awareness of environment' which we saw in the 1916 portrait of Johann Harms; in the portrait of Hugo Koller (Fig. 12), for example, more attention is paid to the subject's actual space than in any of his portraits hitherto. The space is now a domestic one, which contributes

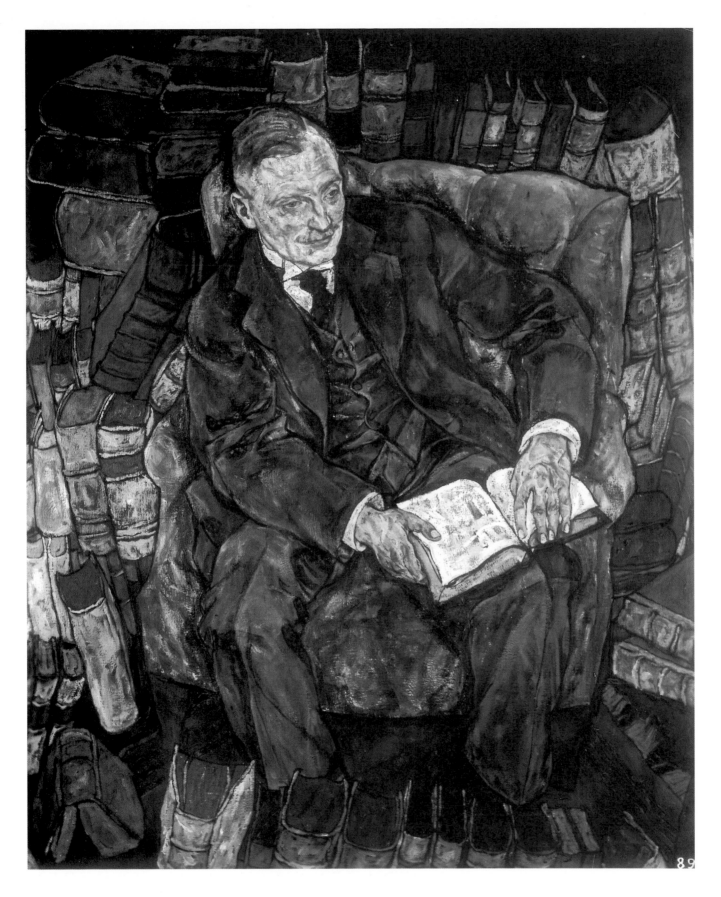

Fig. 12
Portrait of
Dr Hugo Koller
1918. Oil on canvas,
140.3 x 109.6 cm.
Österreichische Galerie,
Vienna

Fig. 13
Reclining Woman
1917. Oil on canvas,
95.5 x 171 cm.
Rudolf Leopold
Collection, Vienna

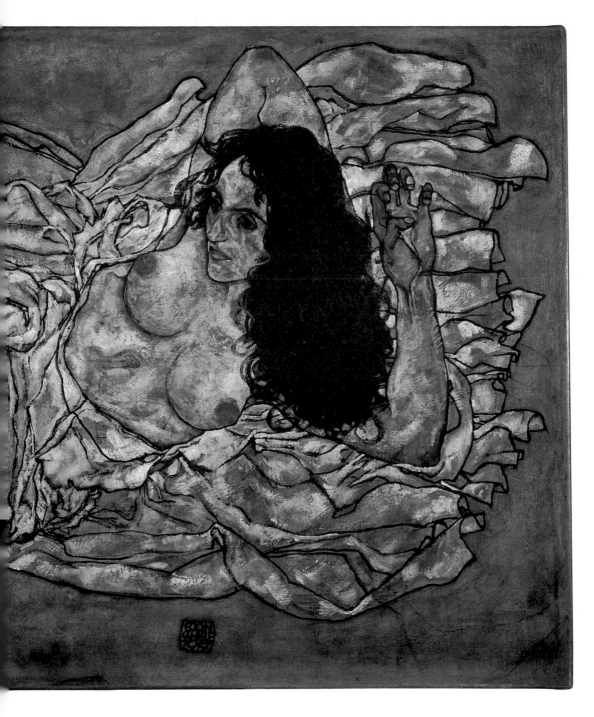

to our understanding of the sitter's character, as opposed to the blank space of so many earlier portraits and figure pieces which contributes to our sense of the sitter's psychic condition. These later portraits are a continuation of that new humanism we first saw in the allegorical paintings on the theme of motherhood.

During 1917 and 1918 Schiele continued to produce large numbers of figure drawings, which also show a stylistic development. In 1914 and 1915, he had produced a number of representations of women with facial features reminiscent of dolls (Fig. 25); the result was a characterless, lifeless persona, frequently with a sexually provocative body. Certain nude drawings of 1917 and 1918 develop this loss of personality, giving rise to a monumentality that is also typical of nudes executed in oil during these years. Sketches are as sexually explicit as before, yet the underlying sexual urgency is diminished, most obviously in the indifferent facial expression; a few years earlier this would have been one of ecstasy. In *Reclining Woman* of 1917 (Fig. 13), we are struck not only by the balanced composition of the whole, the

completeness of form – nothing is 'cut off' by the frame – but also by the precision with which paint is applied, both in lines and across surfaces, marking a profound difference from the nervous, angular gestures of his earlier pieces. These technical and stylistic changes suggest a growing detachment in his attitude to his subjects.

This detached manner of representation came to dominate Schiele's later allegorical works and his self-portraits. In the unfinished 1918 painting *Man and Woman II (Lovers III)* (private collection), for instance, the woman is accompanied but apparently unaffected by Egon himself. Such is the fate of the self-portrait, just eight years earlier the most radical, egocentric form in Schiele's art; it is as if the individual psyche is now given over to the allegorical, to the commonality of shared experience which in earlier representations of the self was all but absent.

What might have been Schiele's ultimate creation, the child which Edith discovered she was carrying in April or May 1918, never happened. On 28 October she died of the same Spanish influenza epidemic which killed Klimt earlier that year. In spite of precautions, it was only a few days later that Schiele himself was taken ill. In Edith's family's house on the Hietzinger Hauptstrasse, just about the time old Imperial Austria came to its final end, Egon Schiele died at the age of twenty-eight.

Outline Biography

1890 Egon Schiele is born in the town of Tulln on the Danube, the son of Adolf and Marie Schiele.

1893 Elvira, Schiele's oldest sister, dies at the age of ten. (His other sister is Melanie, born in 1886.)

1894 Schiele's sister, Gertrude (Gerti), who will be the subject of many of his paintings, is born.

1905 After an extended period of illness, Adolf Schiele dies on New Year's day. Egon's uncle, Leopold Czihaczek, becomes his guardian.

1906 Encouraged by Ludwig Karl Strauch, Schiele leaves secondary school at Klosterneuberg to study at Vienna's Academy of Fine Arts.

1907 Egon, with his sisters and mother, moves to Vienna and takes a studio in the city. He becomes acquainted with Gustav Klimt.

1908 Participates in his first public exhibition at the convent of Klosterneuberg. Saw the Kunstschau organized by Klimt and his circle.

1909 Together with a number of classmates, Schiele leaves the Academy on 17 June to form their own group, the Neukunstgruppe. Participates in the International Kunstschau, sequel to the previous year's Kunstschau, at the invitation of Klimt. In December the Neukunstgruppe has its own show at Gustav Pisko's gallery. Here he meets Arthur Roessler, critic of the *Arbeiter-Zeitung*, future friend, patron and critic of Schiele's work.

1911 Moves to Krumau together with his model and partner, Valerie Neuzil. Forced from the town by public opinion, he moves to Neulengbach.

1912 On 13 April Schiele is arrested and imprisoned until 8 May for exposing minors to pornography in Neulengbach. Participates in Vienna Hagenbund in July and in the Cologne Sonderbund. In October, moves to a new studio on the Hietzinger Hauptstrasse, and in December visits Györ in Hungary to paint the wealthy industrialist August Lederer's son.

1914 Schiele learns and attempts to exploit, with little success, the techniques of graphic art, producing a series of etchings. Anton Joseph Trcka produces a series of photographs of Schiele, some of which the the artist alters to become self-portraits. The end of December brings a one-man show organized by the dealer Guido Arnot (the poster for which Schiele designs).

1915 On 17 June Schiele marries Edith Harms. Four days later, he reports to Prague for military service. After a brief period of training in Bohemia, he is assigned for various duties in and around Vienna.

1916 Artistic production meets an all-time low, despite pleasant surroundings and sup portive treatment at his new post in a Russian prisoner-of-war camp in Mühling from May. Publication in September of 'Egon Schiele Issue' of the expressionist periodical, *Die Aktion*.

1917 On 12 January, Schiele is returned to Vienna to work in the Imperial and Royal Military Supply Depot. In May he is asked to arrange the hanging of, and to exhibit in, the Kriegaustellung (War Exhibition) in the Kaisergarten. At the end of September, he is assigned to the army museum in Veinna. In October he is offered membership of the Secession and asked to organize its 49th exhibition for 1918.

Select Bibliography

1918 Schiele dominates the 49th Secession exhibition held in March, exhibiting 19 works. He sells all works, and receives commissions for many more, finally achieving great critical acclaim. On 28 October, Edith Schiele, pregnant, dies of Spanish flu; three days later, Egon Schiele dies of the same illness.

Kallir [-Nirenstein], O., *Egon Schiele. The Graphic Work*, New York and Vienna, 1970.

Comini, A., *Schiele in Prison*, London, 1973.

Comini, A., *Egon Schiele's Portraits*, Berkeley, Los Angeles and London, 1974.

Powell, N., *The Sacred Spring: The Arts in Vienna 1898–1918*, London, 1974.

Mitsch, E., *The Art of Egon Schiele*, London, 1975; 3rd edn., 1993.

Vergo, P., *Art in Vienna 1898–1918: Klimt, Kokoschka, Schiele and their Contemporaries*, London, 1975; 3rd edn., 1993.

Comini, A., *Egon Schiele*, New York, 1976.

Wilson, S., *Egon Schiele*, Oxford, 1980; 3rd edn., 1993.

Whitford, F., *Egon Schiele*, London, 1981.

Varnadoe, K., *Vienna 1900: Art, Architecture and Design*, New York, 1986.

Gordon, D., *Expressionism, Art and Idea*, New Haven and London, 1987.

Schröder, K.A. and Szeemann, H., *Egon Schiele and His Contemporaries. Austrian Painting from 1900 to 1930 from the Leopold Collection, Vienna* (exhibition catalogue), Vienna and London, 1989.

Kallir, J., *Egon Schiele. The Complete Works, Including a Biography and a Catalogue Raisonné*, London, 1990.

Vergo, P., *The Thyssen-Bornemisza Collection, Twentieth Century German Painting*, London, 1992.

Kallir, J., *Egon Schiele*, New York, 1994.

Schröder, K. A., *Egon Schiele: Eros and Passion*, Munich and New York, 1995.

List of Illustrations

Colour Plates

43 Embrace (Lovers II)
 1917. Oil on canvas, 100 x 170.2 cm.
 Österreichische Galerie, Vienna

44 Portrait of the Artist's Wife, Seated
 1918. Oil on canvas, 139.5 x 109.2 cm.
 Österreichische Galerie, Vienna

45 Portrait of the Painter Paris von Gütersloh
 1918. Oil on canvas, 140.3 x 109.9 cm.
 The Minneapolis Institute of Arts

46 Poster for the 49th Secession Exhibition
 1918. Colour lithograph, 68 x 53.2 cm.
 Private collection

47 The Family (Squatting Couple)
 1918. Oil on canvas, 152.5 x 162.5 cm.
 Österreichische Galerie, Vienna

48 Ceramics (Peasant Jugs)
 1918. Gouache, watercolour and charcoal on paper,
 43.2 x 29.2 cm. Private collection

Text Illustrations

Comparative Figures

14 Gustav Klimt
Danaë
1907–8. Oil on canvas, 77 x 83 cm.
Private collection

15 Gustav Klimt
Leda
1917. Oil on canvas, 99 x 99 cm.
Destroyed in 1945

16 Self-Portrait with Hand to Cheek
1910. Gouache, watercolour and charcoal on
paper, 44.3 x 30.5 cm.
Graphische Sammlung Albertina, Vienna

17 Self-Portrait with Spread Fingers
1909. Oil and metallic paint on canvas,
71.5 x 27.5 cm. Private collection

18 Max Oppenheimer
Portrait of Egon Schiele
c1910. Oil on canvas, 47 x 45 cm.
Historisches Museum der Stadt Wien, Vienna

19 Edvard Munch
Puberty
1895. Oil on canvas, 151.5 x 110 cm.
Nasjonalgalleriet, Oslo

20 Reclining Female Nude on Red Drape
1914. Gouache and black crayon on paper,
31.2 x 48 cm. Private collection

21 Prophets (Double Self-Portrait)
1911. Oil on canvas, 110.3 x 50.3 cm.
Staatsgalerie, Stuttgart

22 The Birth of Genius (Dead Mother II)
1911. Oil on wood, 32.1 x 25.4 cm.
Presumed destroyed

23 Van Gogh
Bedroom at Arles
1889. Oil on canvas, 57.5 x 74 cm.
Musée d'Orsay, Paris

24 Krumau Town Crescent I
(The Small City V)
1915–16. Oil on canvas, 109.7 x 140 cm.
Israel Museum, Jerusalem

25 Two Girls, Lying Entwined
1915. Gouache and pencil on paper,
32.8 x 49.7 cm.
Graphische Sammlung Albertina, Vienna

26 Autumn Trees
1911. Oil on canvas, 79.5 x 80 cm.
Private collection

27 Woodland Prayer
1915. Sketchbook, 14 x 8.5 cm.
Graphische Sammlung Albertina, Vienna

28 Transfiguration (The Blind II)
1915. Oil on canvas, 200 x 172 cm.
Rudolf Leopold Collection, Vienna

29 Oskar Kokoschka
The Tempest
1914. Oil on canvas, 181 x 220 cm.
Kunstmuseum, Basle

30 Reclining Woman in Green Stockings
1917. Gouache and black crayon on paper,
29.4 x 46 cm.
Private collection

31 Mother with Two Children II
1915. Oil on canvas, 150 x 160 cm.
Rudolf Leopold Collection, Vienna

32 Mountain Torrent (Waterfall)
1918. Oil on canvas, 110.2 x 140.5 cm.
Private collection

33 The Friends (Round Table), Large
1918. Oil on canvas, 100 x 119.5 cm.
Private collection

34 Squatting Women
1918. Oil and gouache on canvas, 110 x 140 cm.
Rudolf Leopold Collection, Vienna

1 Portrait of Leopold Czihaczek

1907. Oil on canvas, 149.8 x 49.7 cm. Private collection, Vienna

When Schiele's father died in 1905, his uncle, Leopold Czihaczek, became his guardian. Also an employee of the railways, he held office of higher rank than Adolf Schiele and was significantly wealthier. Czihaczek had a great love of music, but he had less time for the visual arts and was even more ardently opposed to his godson's wish to train as an artist than the boy's father. When Schiele gained a place at the Academy of Fine Arts in 1906, he moved to Vienna, where his uncle lived, and seems to have had considerable contact with him and his family; none the less, it is clear that relations between uncle and nephew were strained, though Schiele did produce numerous studies and portraits of him. The present portrait hints at what seems to have been Czihaczek's stilted, almost pompous, middle-class character. The formal, academic manner, particularly the vertical division of form into areas of distinct tonal contrast, is very much a product of Schiele's first year in the Academy. The technical competence displayed in this work would serve Schiele well as he developed and manipulated artistic form through various, decidedly non-academic modes of representation in the ensuing years.

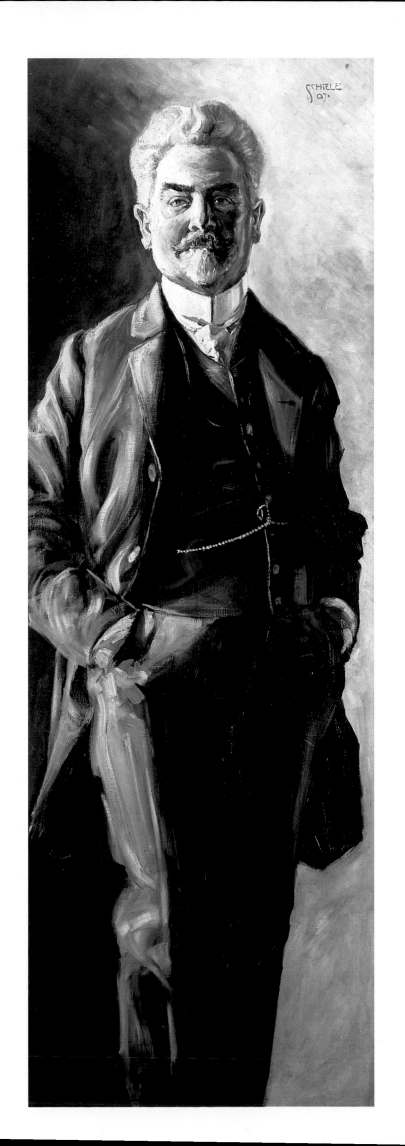

Harbour of Trieste

1907. Oil and pencil on board, 25 x 18 cm. Neue Galerie am Landesmuseum
Joanneum, Graz

During 1907 and 1908, Schiele executed a series of studies of boats in the
harbour at Trieste, a town he frequently visited, often with his sister,
Gerti. While the boats with their rigging tell of a highly competent
draughtsman and painter, their distorted reflections in the water suggest
concern for a linearity reminiscent of Art Nouveau. To achieve this effect,
Schiele developed the method of scoring wet pigment with a pencil.
While apparently quite innocuous, this technique marks the work as
something done outside the Academy, a product of the artist's extra-
curricular concerns. At this stage, Schiele was still not allowed to paint at
the Academy, least of all in the manner of the Secession, whose
exhibitions had been made out-of-bounds to students by Schiele's
authoritarian teacher, Professor Christian Griepenkerl. Conceiving of any
significant deviation from traditional academic teaching as an assault not
only on tradition, but on his own values, Griepenkerl did his utmost to
stifle his students' creativity. As far as Schiele was concerned, his
proclamations were to be ignored as he familiarized himself with Vienna's
avant-garde, and the Secessionist circle which gathered around Gustav
Klimt in particular. The present painting is thus to be seen both as a
formal experiment and as a mark of significant opposition.

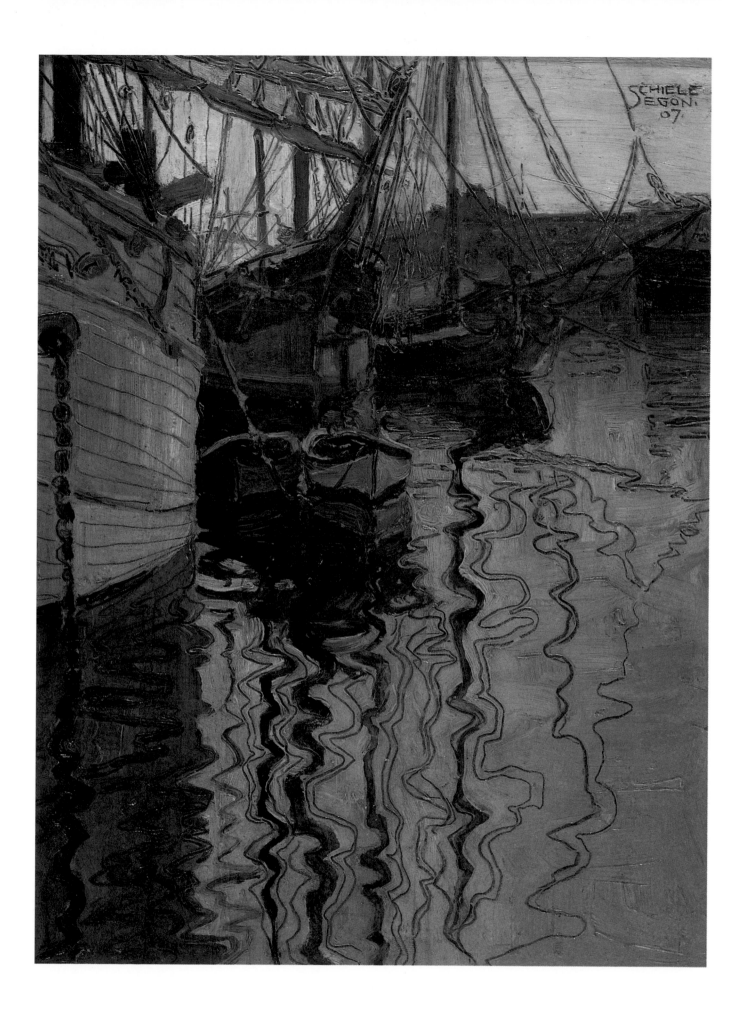

Portrait of the Painter Anton Peschka

1909. Oil and metallic paint on canvas, 110.2 x 100 cm. Private collection

Anton Peschka was a classmate of Schiele's in the Academy and a fellow member of the Neukunstgruppe (New Art Group), formed by Schiele and certain classmates on their departure from the Academy in 1909. In 1914, Peschka would marry Schiele's sister, Gertrude. The influence of Gustav Klimt on this painting, both in the elegant line with which form is depicted and in the decorative surface, is clear; such works led Schiele to suggest that he be known as the 'silver Klimt'. Schiele's subject dominates approximately half of the canvas's surface from a lower corner, set against a more or less empty background. Tension is introduced by the face of the subject, which is turned pensively away from the viewer to its own world, and by the hands, which, in a manner to which we shall return, are extended in an expressive gesture. We may isolate three separate components of the painting: the decorative surface which articulates the presence of the chair on which Peschka sits, the more or less vacuous background, and the psychologically charged flesh of the sitter. These create a tension which animates the whole picture.

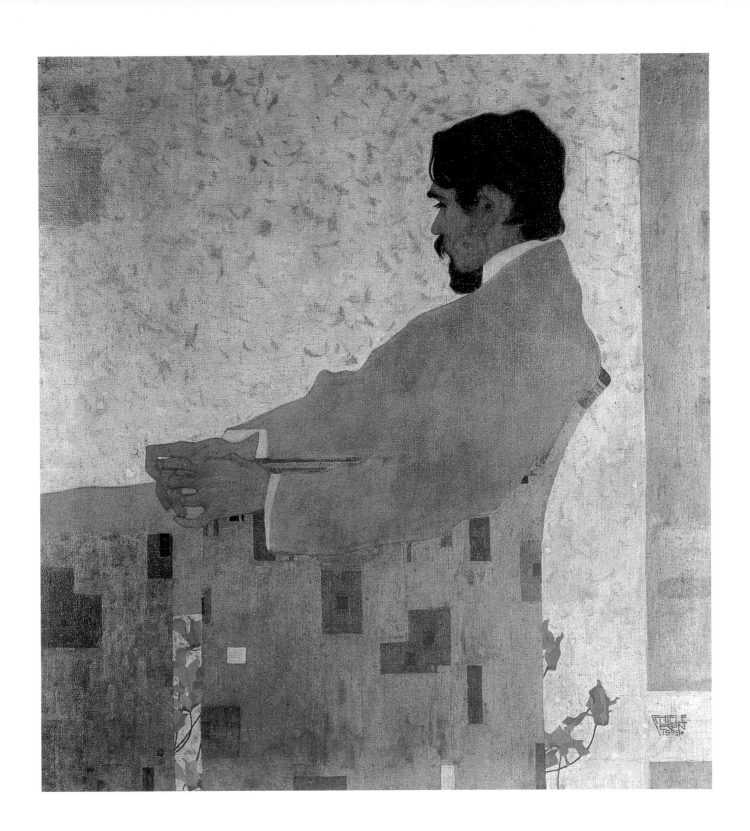

4

Danaë

1909. Oil and metallic paint on canvas, 80 x 125.4 cm. Private collection

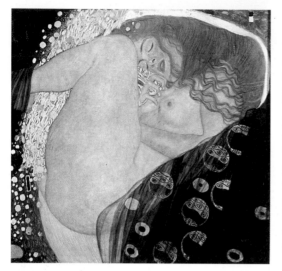

Schiele saw Gustav Klimt's *Danaë* (Fig. 14) at the international Kunstschau of 1908 and responded more or less immediately with his own version of the mythical impregnation of Danaë by Jupiter. In this adaptation of his mentor's theme, Schiele places the figure in an almost foetal position, and the face and clasping fingers, suggestive of ecstatic pleasure, are reflected through a diagonal axis. In this move the figure becomes more introverted, the facial expression less obviously in harmony with events. Schiele does outline details of the human form, but with the faintest of lines; far more attention is paid to the detail of the bamboo-like branches in the background than to the woman's body in the foreground. Indeed, it is as if in this work Schiele plays upon the abstract form of the curiously positioned body to accentuate its abstractness, reducing all but face and hands to a more or less flat surface. This tension between the abstract and decorative and the representational qualities of the work is one with which Schiele struggles continuously during these first years of engagement with 'Secession style'.

This work is particularly interesting, for through it we can see a double influence; it is clear that Schiele's interpretation of Klimt's piece was in turn picked up and used by Klimt himself in his *Leda* of 1917 (Fig. 15). The female form derives directly from the younger artist's *Danaë*, not only in the way in which knees are tucked uncomfortably tightly to the body, lower legs completely obscured, but in the positioning of one arm over the head, the other about chest height.

Fig. 14
Gustav Klimt
Danaë
1907–8. Oil on canvas,
77 x 83 cm. Private collection

Fig. 15
Gustav Klimt
Leda
1917. Oil on canvas,
99 x 99 cm. Destroyed in
1945

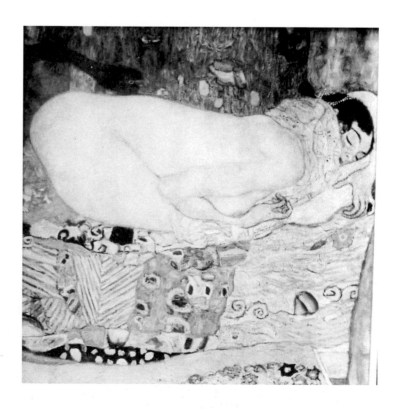

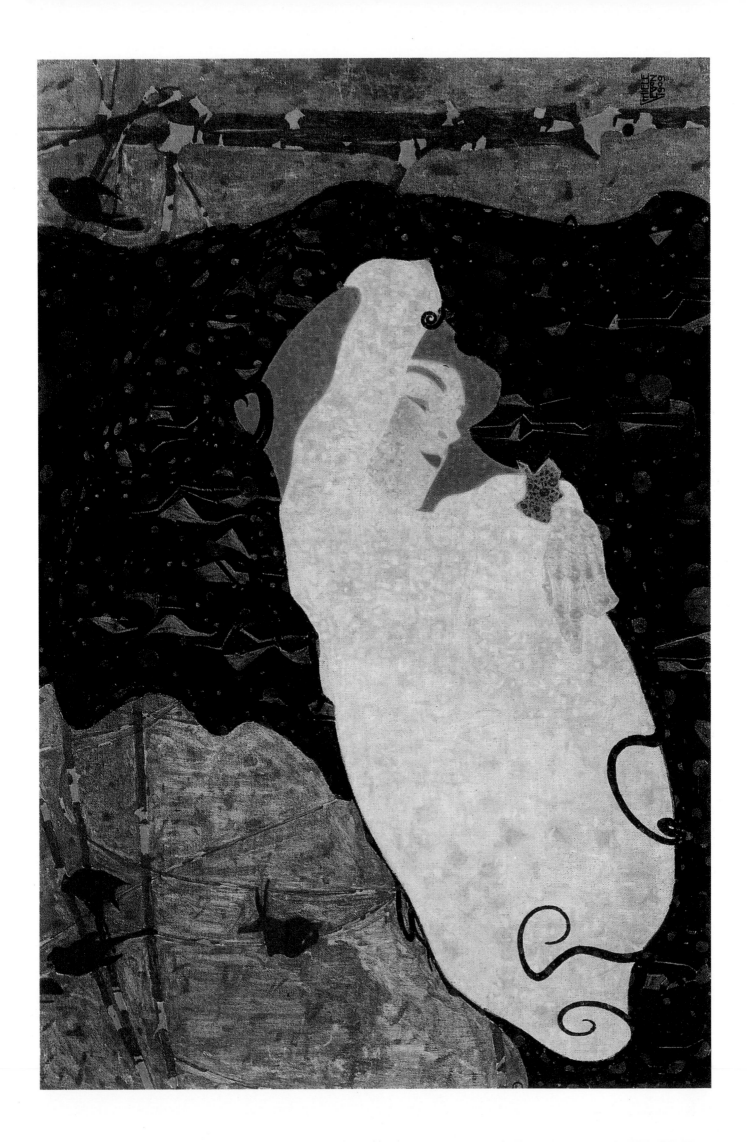

5 Portrait of Gerti Schiele

1909. Oil and metallic paint on canvas, 140.5 x 140 cm.
The Museum of Modern Art, New York

Striking for its simple composition and formal elegance, this painting takes from Secession style the highly elaborate, decorative quality of parts of Schiele's sister's dress and accessories, and sets these in and against relatively sombre colours and simple form. Most remarkable is the stark contrast between form and its absence, between the tower-like figure and the void which constitutes the imposing background. A slightly earlier work, *Woman with a Black Hat (Gertrude Schiele)* (Fig. 2), one of the four paintings which Schiele exhibited in the Kunstschau of 1909, originally had a decorative background, but the artist, in a move away from the influence of Klimt's decorative style, painted it out. In the *Portrait of Gerti Schiele*, the decorative elements are reduced as the artist isolates the subject better to expose it to his and the viewer's analysis. At this stage there is little attempt to probe the psyche of the sitter, but in these two paintings the stage for such an approach is set.

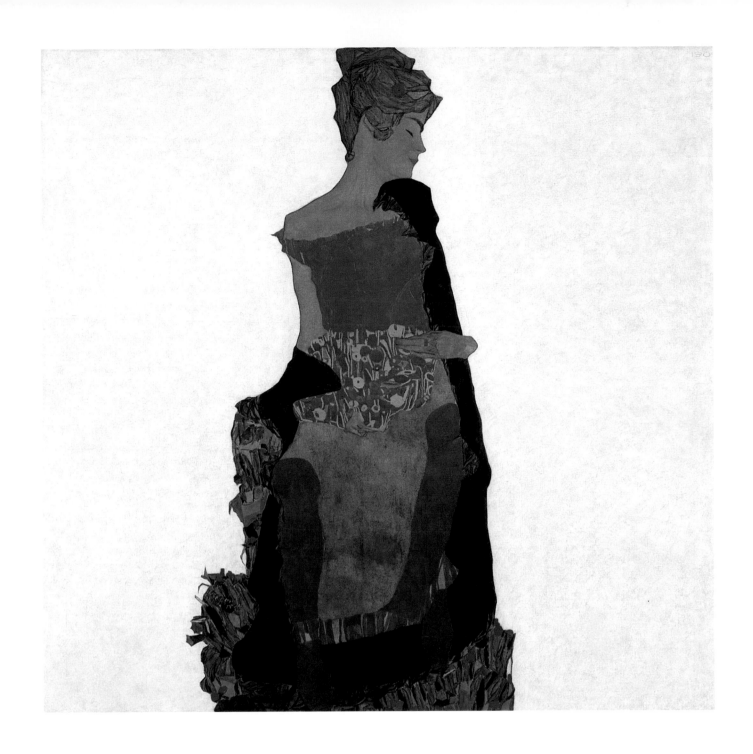

6 Sunflower II

1909. Oil on canvas, 150 x 29.8 cm. Historisches Museum der Stadt Wien, Vienna

42

The stylistic affinity between this painting of a sunflower and Plate 5, the portrait of Schiele's sister, is clear. In particular, they share a single, isolated structure whose form is articulated through a series of taut, almost brittle concave surfaces stretched between extremities which themselves suggest a hidden, almost skeletal armature. The autumnal colours are also important. In his letters and other writings, the artist frequently expressed a fascination with autumn and its decay, a theme which would become dominant in many of his landscapes and representations of plants and trees.

It becomes clear that the sunflower painting, in a certain anthropomorphic sense, is to be read as a portrait, suggesting transience, perhaps even mortality. The work can also be interpreted as a projection of the artist's own state of mind, as an expression of his own anxieties concerning dissolution and death. Whichever way we read the work, it is clear that Schiele is trying to draw to the surface certain states of being and mind which would otherwise remain hidden from view.

The exaggerated vertical format is one frequently used in Art Nouveau, derived from Japanese precedents. A less remote influence, which also exploited the expressive qualities of the sunflower, is the work of Vincent van Gogh, which Schiele would have seen in the 1906 exhibition of his work at the Galerie Miethke, as well as at the 1909 Kunstschau. While there is little stylistic affinity with Van Gogh, thematically there is a clear connection.

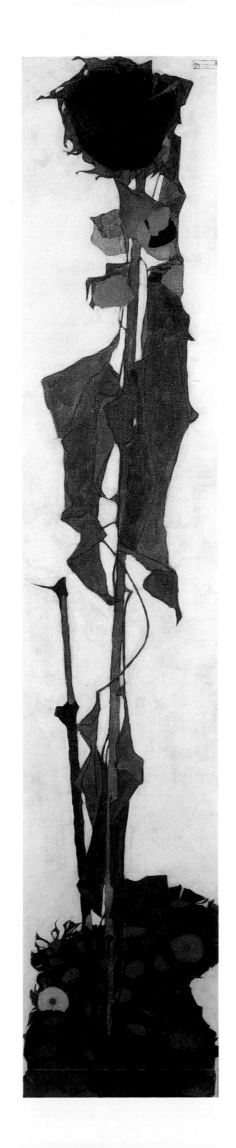

Seated Male Nude (Self-Portrait)

1910. Oil and gouache on canvas, 152.5 x 150 cm. Rudolf Leopold Collection, Vienna

This work is the only known surviving piece from a series of five large nudes which Schiele did in the first half of 1910. In these works, and the large number of studies for them, the stylistic break with Klimt is complete as the artist tears free from the protective world of Secessionist 'illusion' and begins to engage the 'real' more thoroughly. And this reality, it seems, is charged with physical and emotional contradictions and tensions. The self-portrait becomes not just a truncated head and shoulders but the entire body stripped of its protective clothing. The skeletal armature suggested in the discussion of *Sunflower II* (Plate 6) now becomes literal. There is no allusion to autumn as such, but the human form is still threatened by the suggestion of decay so important to the painting of the sunflower. Yet at the same time, the figure is dynamic; the absence of the seat upon which we would assume the figure rests, together with the absence of any feet to stand on, throws the whole into an uncomfortable imbalance. This threat to stability is deepened by sexual instability: the clear suggestion of breasts in the work throws into question the notion of a coherently gendered self. As the young artist struggles to establish his sexual identity he will continue to represent and exploit this sense of ambiguity.

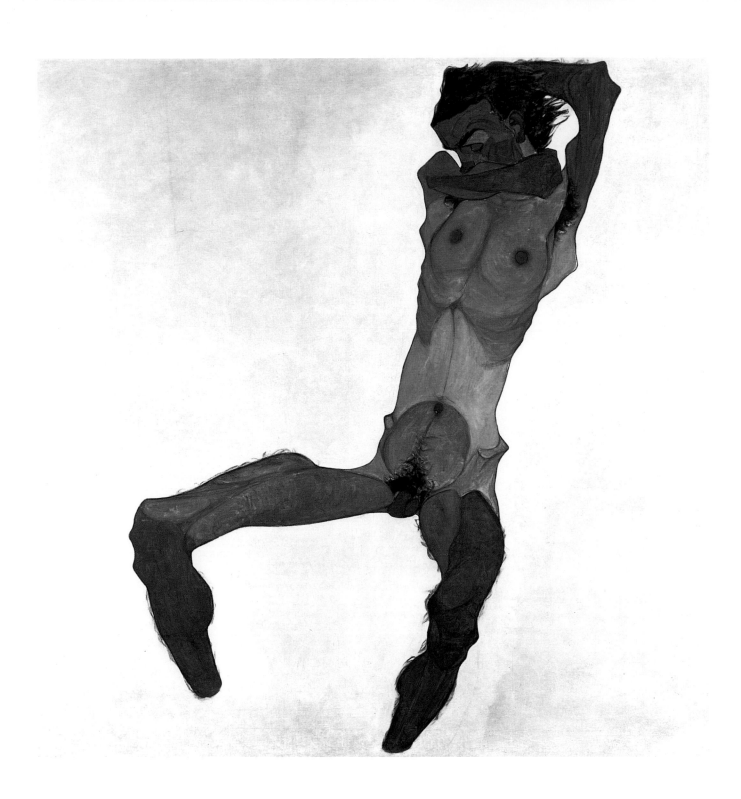

Nude Self-Portrait, Grimacing

1910. Gouache, watercolour and pencil with white heightening on paper, 55.8 x 36.9 cm. Graphische Sammlung Albertina, Vienna

Fig. 16
Self-Portrait with
Hand to Cheek
1910. Gouache,
watercolour and charcoal
on paper, 44.3 x 30.5 cm.
Graphische Sammlung
Albertina, Vienna

Fig. 17
Self-Portrait with
Spread Fingers
1909. Oil and metallic
paint on canvas,
71.5 x 27.5 cm.
Private collection

Nude Self-Portrait, Grimacing is one of many experiments in self-portraiture made during 1910 which, along with other portraits, mark a significant break with earlier works influenced by Secession style. As in *Self-Portrait with Hand to Cheek* (Fig. 16), Schiele uses gestural areas of colour on the subject's body to exploit their potential for articulating states of mind and emotions. Schiele also adopted, for the same expressive purpose, a range of hand gestures and positions which seem to have developed into something of a private language. In both these works, as in many portraits to follow, hands are almost skeletal, and knuckles and joints swell painfully through taut skin. In *Self-Portrait with Spread Fingers* (Fig. 17), the artist experiments with specific gestures of hands which, combined with faces, become the essential content of portraits. These gestures appear in many works of the period, and scholars have debated their historical and psychological significance. It seems likely that for Schiele the meaning of these frequently bizarre, sometimes painful looking contortions may well lie in the hermetic world of the occult, which was of great interest to certain members of the avant-garde at the time, and which led to experiments with the spiritual significance of bodily gestures.

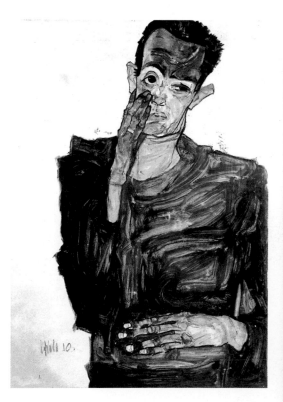

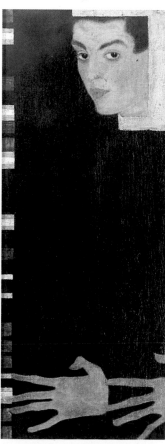

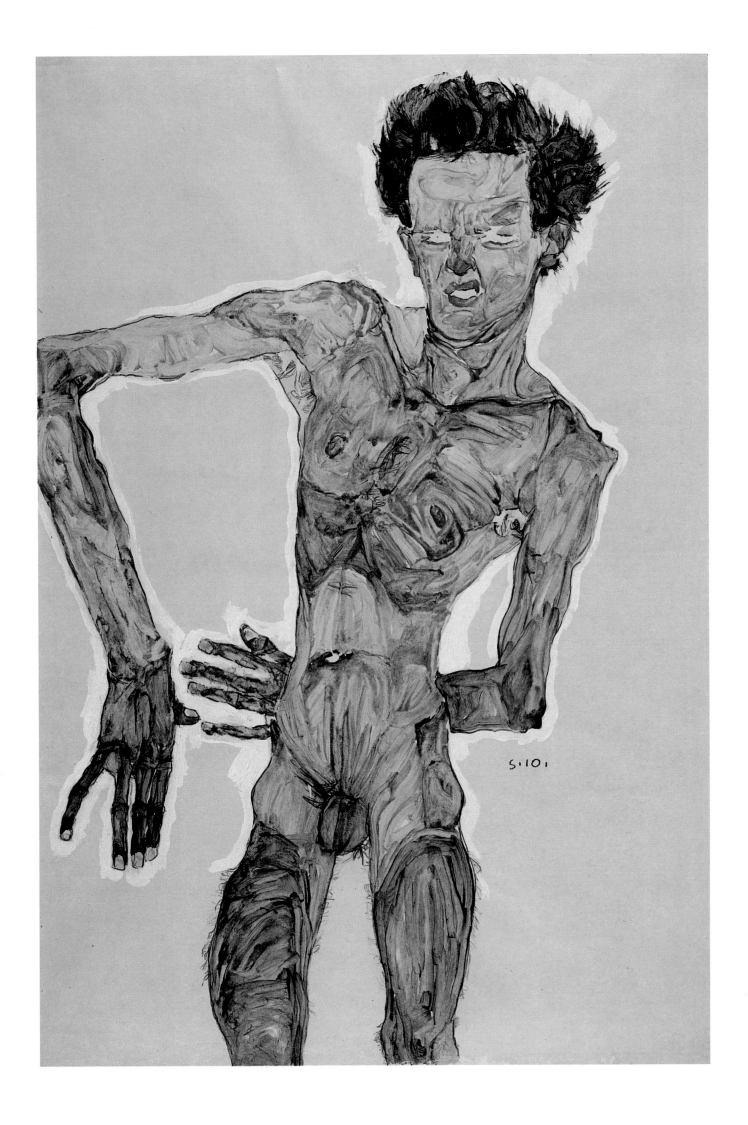

The Painter Max Oppenheimer

1910. Watercolour, ink and black crayon on paper, 45 x 29.9 cm. Graphische Sammlung Albertina, Vienna

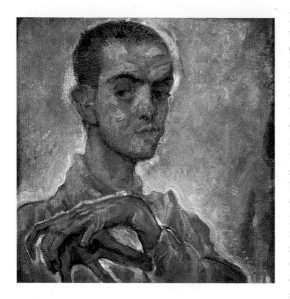

Fig. 18
Max Oppenheimer
Portrait of Egon Schiele
*c*1910. Oil on canvas, 47 x 45 cm.
Historisches Museum der
Stadt Wien, Vienna

Max Oppenheimer ('Mopp') was five years older than Schiele, and one of the artists responsible for establishing Austrian Expressionism. He contributed several pictures to the 1908 Kunstschau, and, before his move to Berlin in 1911, undertook portraits of a number of Vienna's famous musicians and men of letters. It was in 1909 that Schiele discovered Oppenheimer; apparently, their first meeting lasted no less than two days and three nights, during which they wandered the streets of Vienna and its surrounds, excitedly exchanging ideas on art. For months after this, the two artists worked together, and among other things each produced a portrait of the other. The portraits are striking not so much for the similar quest for some expressive account of the subject, but for the marked difference in the way this is achieved. While Oppenheimer works with solid, three-dimensional forms presented in a painterly manner, Schiele's work, while not lacking in painterly qualities, reduces form to the flatness of the paper, only hand and face in any way suggesting three-dimensional space. Through quite different means (excepting the near three-quarter view of the face and the similarly expressive gesture of the hands), both artists strive to penetrate their subject's psyche.

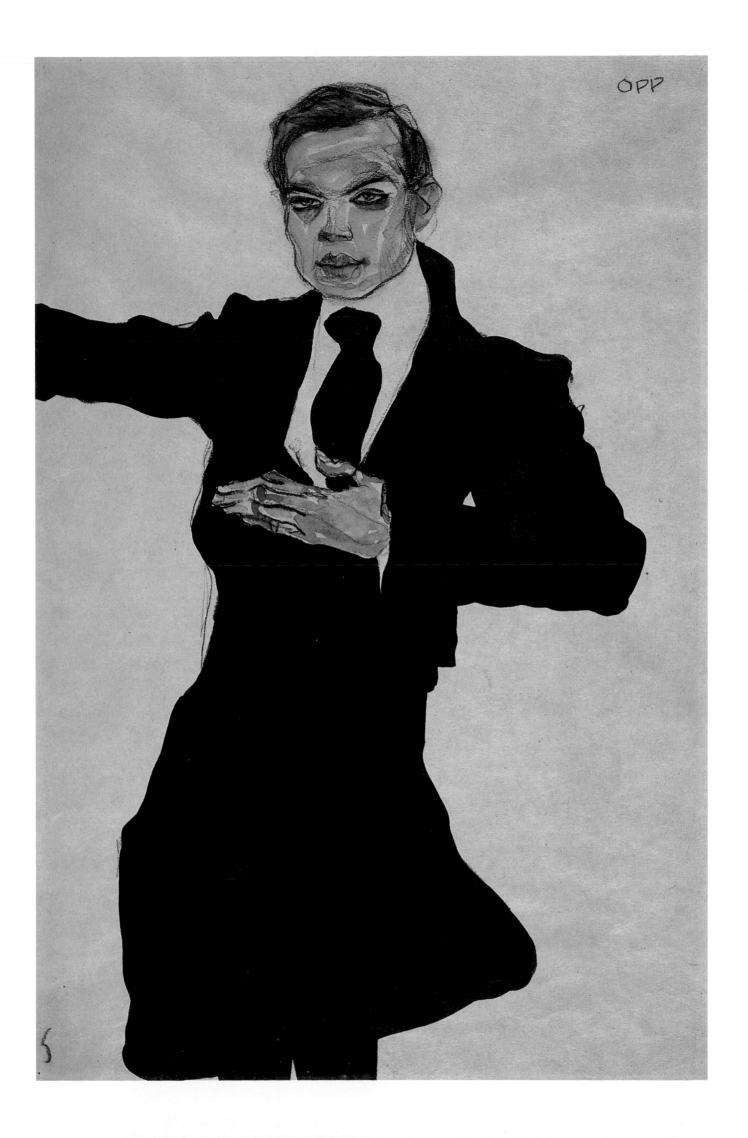

10 Portrait of Arthur Roessler

1910. Oil on canvas, 99.6 x 99.8 cm. Historisches Museum der Stadt Wien, Vienna

This painting is one of Schiele's first commissioned portraits, thought to have been executed in mid-September 1910. Schiele first met Arthur Roessler, collector, art critic of the *Arbeiter Zeitung* and consultant to the Galerie Miethke, in 1909. Widely travelled throughout Europe, he published several books on subjects as diverse as a travelogue on Dalmatia and a monograph on Waldmüller; more important in the present context are the many texts he produced on the work of Egon Schiele. The first was a favourable review of the New Art Group's 1909–10 show at the Pisko Salon, in which he singled out Schiele's work for special praise. Immediately they met, they initiated an enduring friendship which would support the painter's career both financially and emotionally. The 'rosy-red Roessler', as Schiele himself described *Portrait of Arthur Roessler*, bears a certain resemblance, in the contorted posture, head facing one way, knee completely the opposite, to certain nude self-portraits; it also bears a resemblance to his *Portrait of Gerti Schiele* (Plate 5), which shows in less extreme form the same posture.

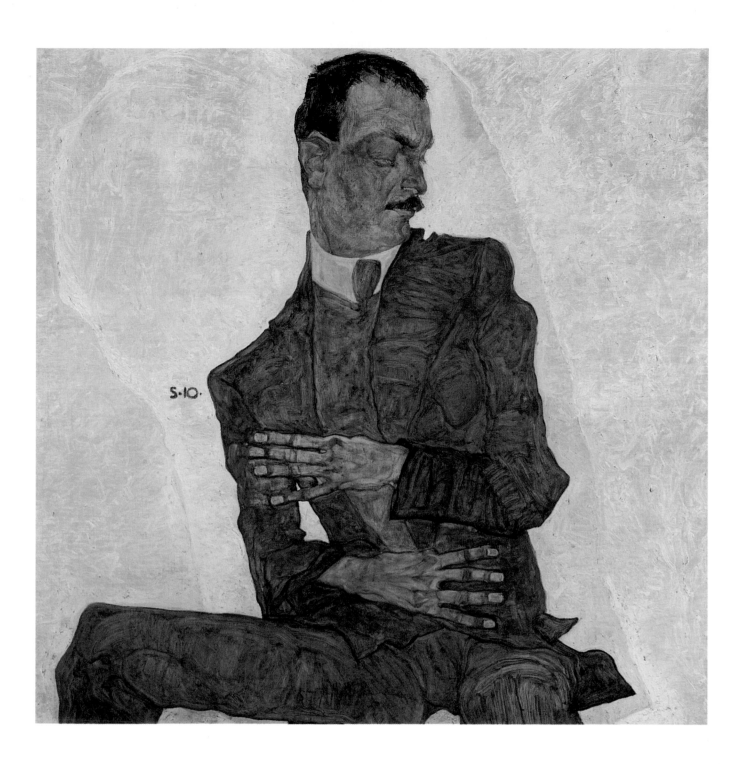

Portrait of the Publisher Eduard Kosmack

1910. Oil on canvas, 100 x 100 cm. Österreichische Galerie, Vienna

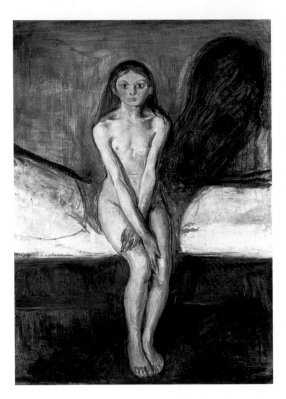

Fig. 19
Edvard Munch
Puberty
1895. Oil on canvas,
151.5 x 110 cm.
Nasjonalgalleriet, Oslo

Schiele was introduced to Eduard Kosmack, publisher of two important avant-garde design magazines, by Arthur Roessler, who acted as editor of one of them, *Das Interior*. The commission was the last of 1910. Gone are the acrobatic contortions of many other portraits which date from this year; in their place sits Kosmack, just slightly left of centre, staring maniacally at the viewer from an almost vacant space. In the background we notice what resemble claw marks down the beige wall, and to the right, a large sunflower. With his posture and concave profile, the figure seems withdrawn; yet, with hands placed almost nervously between the legs as though to protect himself, he simultaneously appears exposed, as the limp, vascular thumbs hang down, suggestive of genitals. As the world presses upon and threatens the subject, however, he seems to possess a certain power; the gaze which pierces the viewer has been associated with Kosmack's amateur practice of hypnotism, a form of psychic manipulation which could not have failed to interest Schiele. The sitter's position has an obvious similarity to that of the young girl in Edvard Munch's *Puberty* (Fig. 19). More subtle is the relationship of the large, dark form which looms menacingly behind the girl in Munch's work (and which finds an echo in the large, billowing shape which hovers almost unseen behind the sitter in the *Portrait of Arthur Roessler*, Plate 10) to the more or less empty space, scored aggressively with lines, which threatens Kosmack.

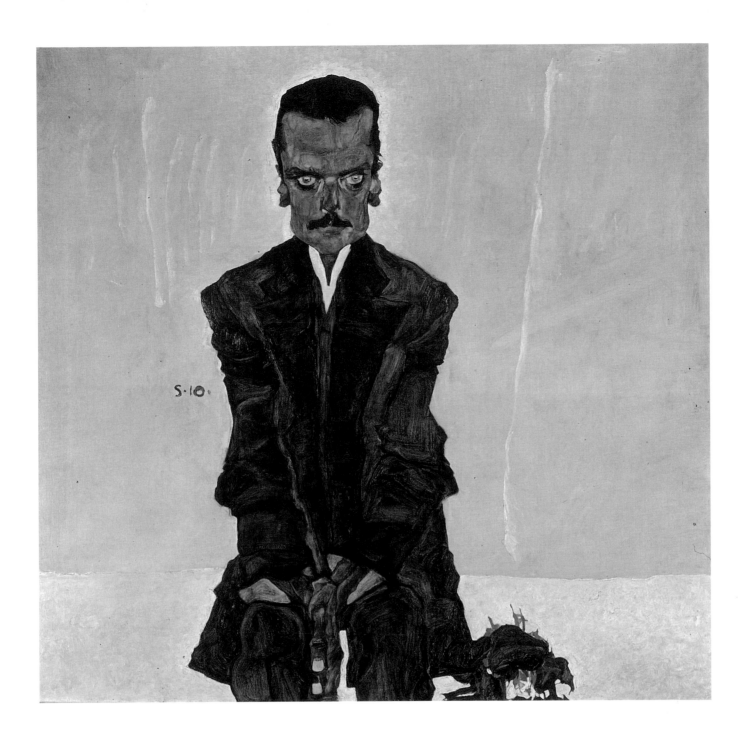

Self-Portrait, Nude

1910. Gouache, watercolour and black crayon with white heightening on paper, 44.9 x 31.3 cm. Rudolf Leopold Collection, Vienna

In attempting to expose the whole self through his full-length self-portraits from 1910, Schiele revealed a complex of anxieties and ambiguities (see Plate 7). But in *Self-Portrait, Nude,* the artist's identity is clear: the portrait is quite unambiguously of the self as symbol of the masculine, as phallus. In order to achieve the visual similarity (stomach as shaft, bottom of ribcage as lower edge of glans), Schiele has dismembered the torso, simultaneously presenting in symbolic (as opposed to actual) form the castration which Freudian analysis suggests is feared as a punishment for masturbation.

Not only did Schiele produce a series of works which presented himself in the unambiguous form of the penis, but he represented woman in the form of female genitalia. Thus, in *Reclining Female Nude on Red Drape* (Fig. 20), we see not only the woman as described in the work's title, but a clear suggestion of vulvic form (the drape) and the presence of the erect clitoris (the woman's head). While there are precedents for such a manner of representation in the history of Western art (just a few years earlier, Klimt had sketched a self-portrait as genitalia), these works constitute a radical attack not only on academic traditions, but on the rational, bourgeois individual who was the very fabric of conventional Viennese society.

Fig. 20
Reclining Female Nude
on Red Drape
1914. Gouache
and black crayon on paper,
31.2 x 48 cm.
Private collection

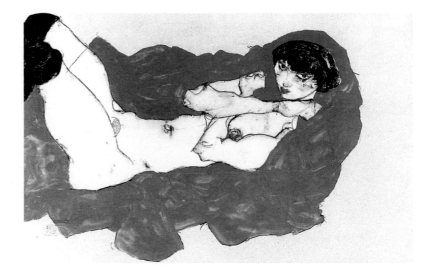

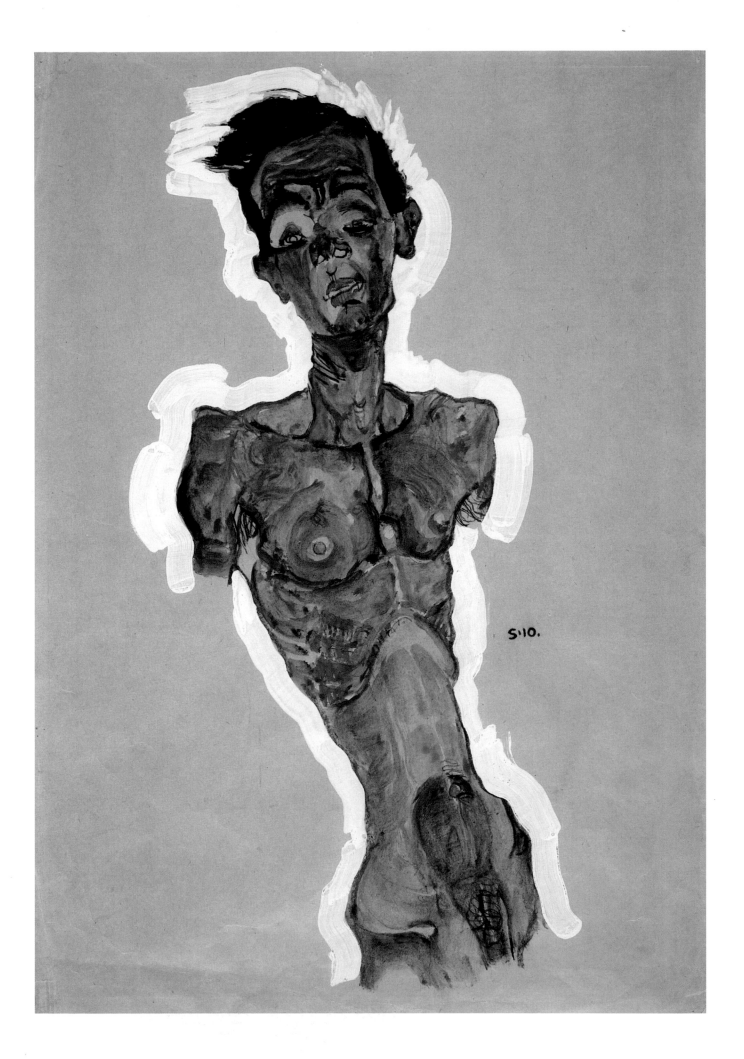

Self-Seers II (Death and Man)

1911. Oil on canvas, 80.3 x 80 cm. Rudolf Leopold Collection, Vienna

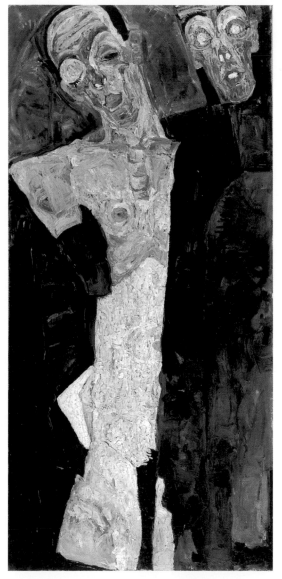

Fig. 21
Prophets
(Double Self-Portrait)
1911. Oil on canvas,
110.3 x 50.3 cm.
Staatsgalerie, Stuttgart

Self-Seers I (Fig. 8) and *Prophets (Double Self-Portrait)* (Fig. 21) join with *Self-Seers II* to form a series which differ markedly from previous single self-portraits. The works are allegories, which is to say that each work, though it represents a particular situation or event, has more general and abstract meaning which the viewer must decode from what is given. The subtitle of the present work directs us clearly towards the theme of life and death, which has a long tradition in German art; the motif of death stalking its victim runs from the Middle Ages through the art of Dürer to the late nineteenth and early twentieth centuries in the work of such artists as Arnold Böcklin and Lovis Corinth. Schiele would develop the related and highly popular theme of 'Death and the Maiden' in a work of that title in 1915 (Plate 34).

In *Self-Seers I* Schiele was able to be simultaneously masculine and feminine. In *Prophets* this theme is dropped as the prophetic 'seers' – one nude, one clothed – seem to become detached from the world of contradiction and difference in their sightless vision; the only eye which has not been reduced to a blind orb is, it appears, all but closed to the visual world. The work becomes both visually and conceptually less corporeal and more spiritual, a progression which is developed more fully in *Self-Seers II*. In this last, the figure to the front is more realistically represented than the other which, with its skull-like head, is clearly that of death, yet both are now completely sightless and represented in a more abstract manner. Death joins life in a confused embrace as a large spectre-like profile looks on from the right side of the canvas. Of this profile we can only make out clearly the eyeball and socket, reminiscent of the abstract portraits by the Viennese musician Arnold Schoenberg (of whom Schiele had executed a number of portrait studies). As the third 'self' in the painting, Schiele looks upon his other selves, witness to the death of any secure notion of personal identity.

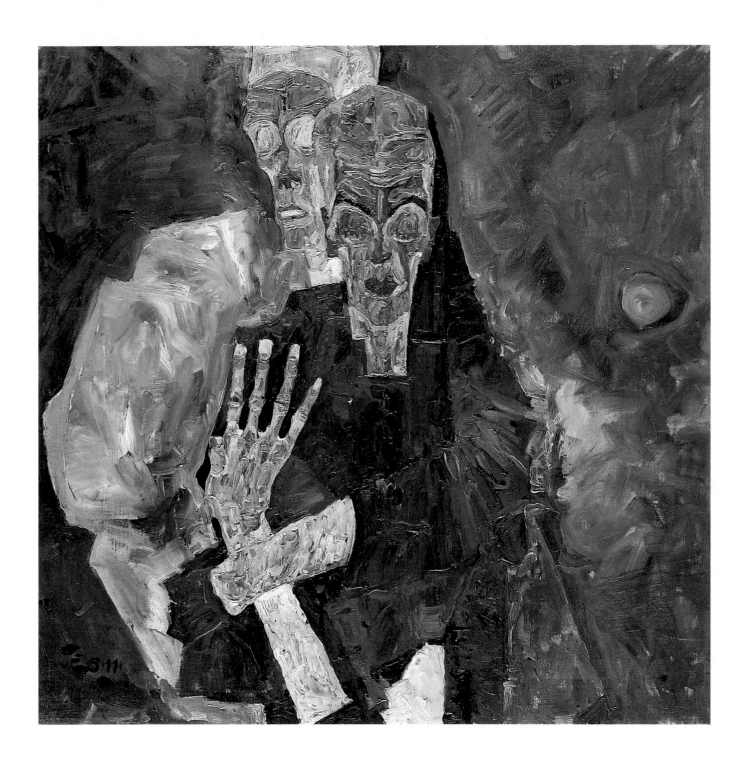

Self-Portrait in Black Cloak, Masturbating

1911. Gouache, watercolour and pencil on paper, 48 x 32.1 cm. Graphische Sammlung Albertina, Vienna

Though still considered radical in the context of the fine arts, by 1911 masturbation had already become a familiar topic among certain avant-garde artists and among theoreticians. From Frank Wedekind's *Spring's Awakening*, in which a youth masturbates over and eventually destroys a reproduction of Palma Vecchio's *Venus*, to the psychoanalytical speculations of Freud, the theme assumed a sense of urgency.

In Schiele's treatment of the subject, the present painting represents something of a resolution. Gone are the suggestions of punishment and castration which accompanied certain nude self-portraits of this and the previous year (for example, Plate 12), as the artist presents a frank, almost matter-of-fact portrayal of himself masturbating. Yet, just as we might think Schiele has settled to a single (masculine) sexual identity with a particular object in relation to which he seeks gratification (woman, as presented in his many representations of her), he once again complicates the issue. The fingers of both hands, as well as performing as the title describes, mask his masculinity and, in the narrow space between index and middle finger of his left hand, frame the fleshy folds in a way that suggests the lips of the female genitalia.

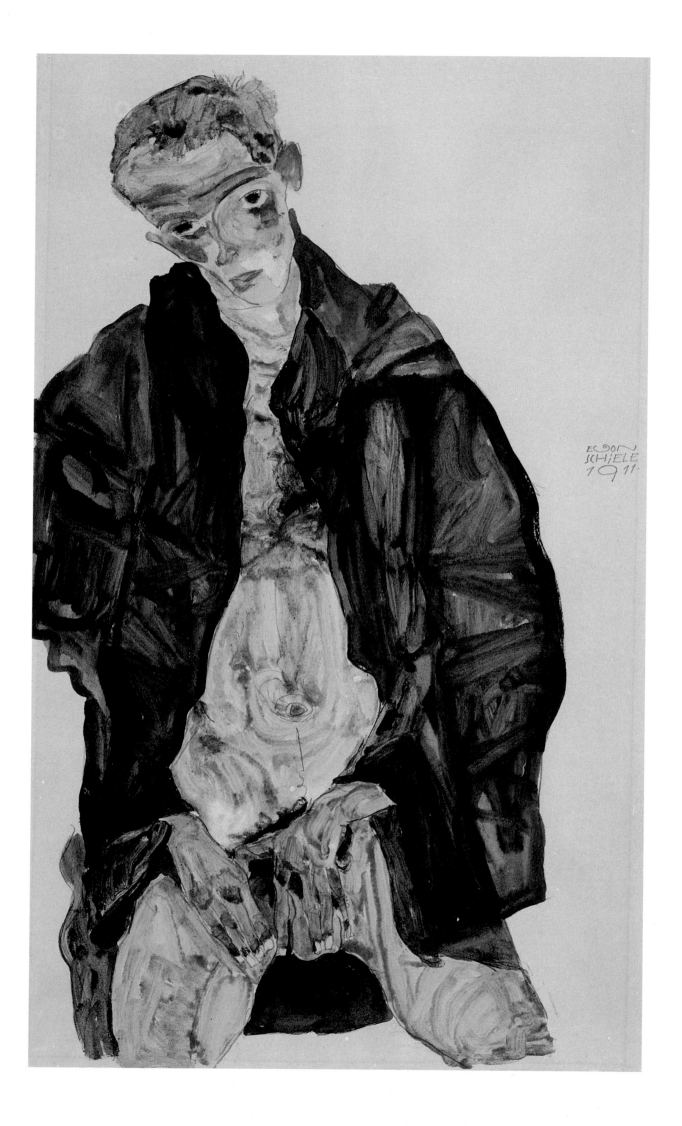

Observed in a Dream

1911. Watercolour and pencil on paper, 48 x 32 cm.
The Metropolitan Museum of Art, New York

The title of this work, *die Traum-Beschaute*, is ambiguous: simultaneously it tells us that what is represented is a girl dreaming and acting in accordance with the dream; and it tells us that the picture shows us what is observed in a dream, presumably by Schiele himself. It is the female equivalent of *Self-Portrait in Black Cloak, Masturbating* (Plate 14); the clear difference is that the artist and viewer are here voyeurs, looking on apparently uninvited and unacknowledged. It is as if little or no effort is made to treat the person's psyche. In place of the probing, questioning manner of the self-portraits and other nude portraits of 1910 and 1911 (for example, Fig. 7), we find little other than the erotic. Particularly in his drawings and watercolours of young girls such as *Black Haired Nude Girl, Standing* (Fig. 9), Schiele drew attention to the children's sexuality, frequently by use of vivid crimsons to represent vagina, nipples and lips. It it clear that these works, which in 1911 outnumbered the drawings of young boys, sold well as pornography, and that Schiele (in spite of later protestations to the contrary) exploited that market.

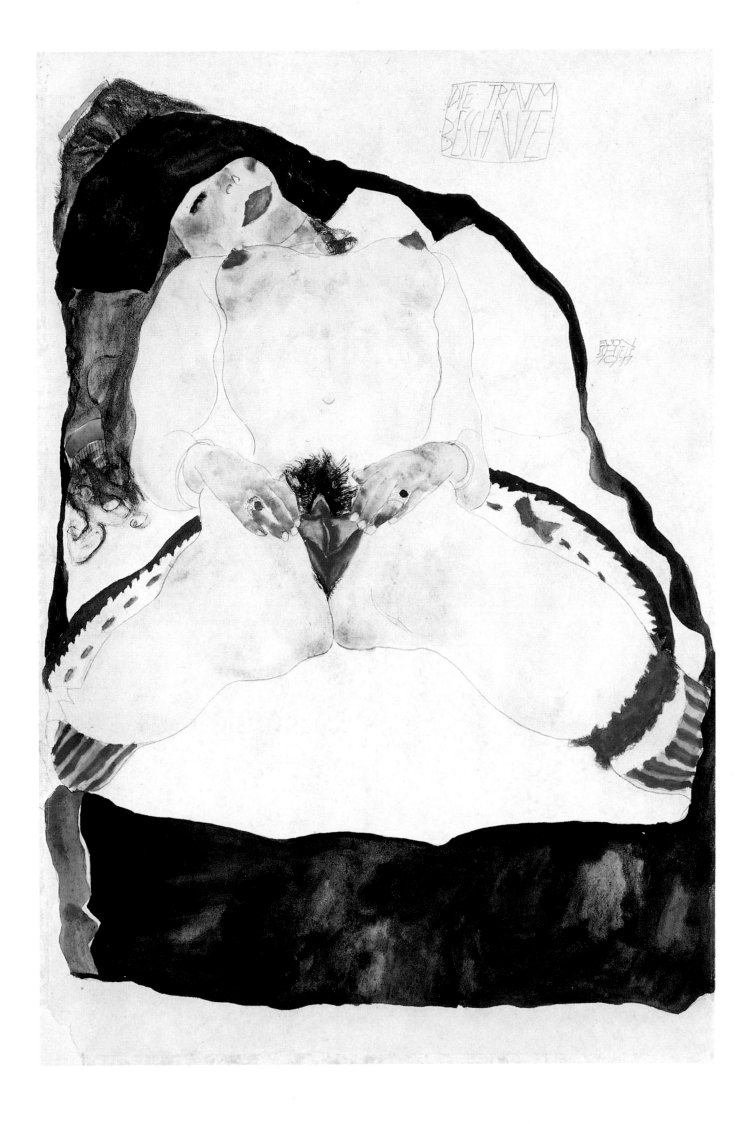

Pregnant Woman and Death

1911. Oil on canvas, 100.3 x 100.1 cm. Národní Galerie, Prague

Fig. 22
The Birth of Genius
(Dead Mother II)
1911. Oil on wood,
32.1 x 25.4 cm.
Presumed destroyed

Schiele turned repeatedly to the theme of death. From sunflowers, trees and townscapes to self-portraits we encounter the artist's morbid assertion that 'all is living death'. The two works presented here both make a claim to allegorical status, treating a theme ancient to the visual arts, Mother and Child. Through exhibitions and reproductions in periodicals, Schiele would have come to see variations on the theme by recent contemporaries as diverse as Max Klinger, Giovanni Segantini and Edvard Munch. Yet Schiele's versions are in important ways autobiographical.

The series of *Dead Mother* works began on Arthur Roessler's recommendation following a conversation in which Schiele complained of his mother's failure to understand his needs. Roessler suggested that he treat the theme of motherhood in a series of works in order to resolve his feelings toward his own mother. The dead mother, then, is to be read partly as a product of artistic tradition, and partly as a product of the artist's analysis of his relations with his mother. But Schiele's mother's failure to understand his needs is unlikely to account for the untimely death he imposes upon her. Schiele appears to be working out a more complex problem in these works. At an allegorical level, *Pregnant Woman and Death* may be read as Fate, in the morbid form of Death, confronting its opposite, Life. At the autobiographical level, we are presented with a family portrait in which Schiele's father brings both life (in the form of a son) and death (in the form of the syphilis of which he died) to his wife and child. As well as the actual death of the father, the disease brought the threat of illness to both mother and her children, a threat Schiele is known to have felt at certain moments of his life. The birth in *The Birth of Genius (Dead Mother II)* (Fig. 22) is surrounded by the threat of death, a threat signified in the actual death of the mother. The only hope which remains of this event is the self-proclaimed genius of the artist himself; to his mother, he wrote in 1913: 'I shall be the fruit which after its decay will still leave behind eternal life; therefore how great must be your joy – to have borne me?'

17 The Artist's Room in Neulengbach
(My Living Room)

1911. Oil on wood, 40 x 31.7 cm. Historisches Museum der Stadt Wien, Vienna

In 1911 Schiele and his partner and model, Valerie Neuzil, had tried to settle in the small town of Krumau, but were forced to leave because of public disapproval of their lifestyle. After a brief return to Vienna, they tried again, moving to a house in the rural town of Neulengbach, a short train ride from the capital. Here Schiele was so impressed with his new surroundings that for the first time he equipped the house with his own furniture, much of which came from the family home in Tulln. Here he painted *The Artist's Room in Neulengbach (My Living Room)*, which clearly derives from Vincent Van Gogh's *Bedroom at Arles*, which he would have seen at the 1909 Kunstschau, and a version of which was in the private collection of Carl Reininghaus, a collector whom Schiele had met in 1909.

The painting is one of the type Schiele called *Bretterl*, little boards upon the smooth surface of which thin layers of paint were applied, producing a somewhat luminous yet painterly effect. Compared with the sense of desperate loneliness and confinement conveyed by the Van Gogh interior, Schiele's space is light, colourful and open, a contrast made more obvious by the absence of clearly defined corners. There is a sense of contentment and a certain stability in the painting of the artist's new quarters, an order that is implied in the regular geometric shapes which decorate bed linen and ceramic forms alike. All this was shattered at the hands of the local police a few months later, when Schiele was forced to exchange the freedom of his own living room for the confine of a prison cell as, once again, the opinion of the local community turned against him.

Fig. 23
Vincent Van Gogh
Bedroom at Arles
1880. Oil on canvas,
72 x 90 cm. Rijksmuseum
Vincent Van Gogh,
Amsterdam

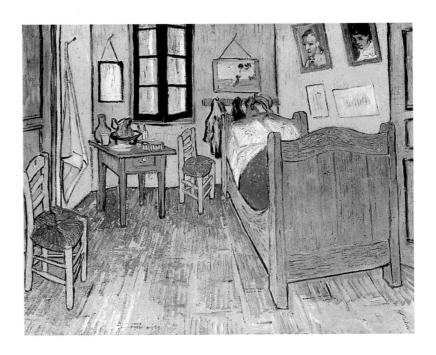

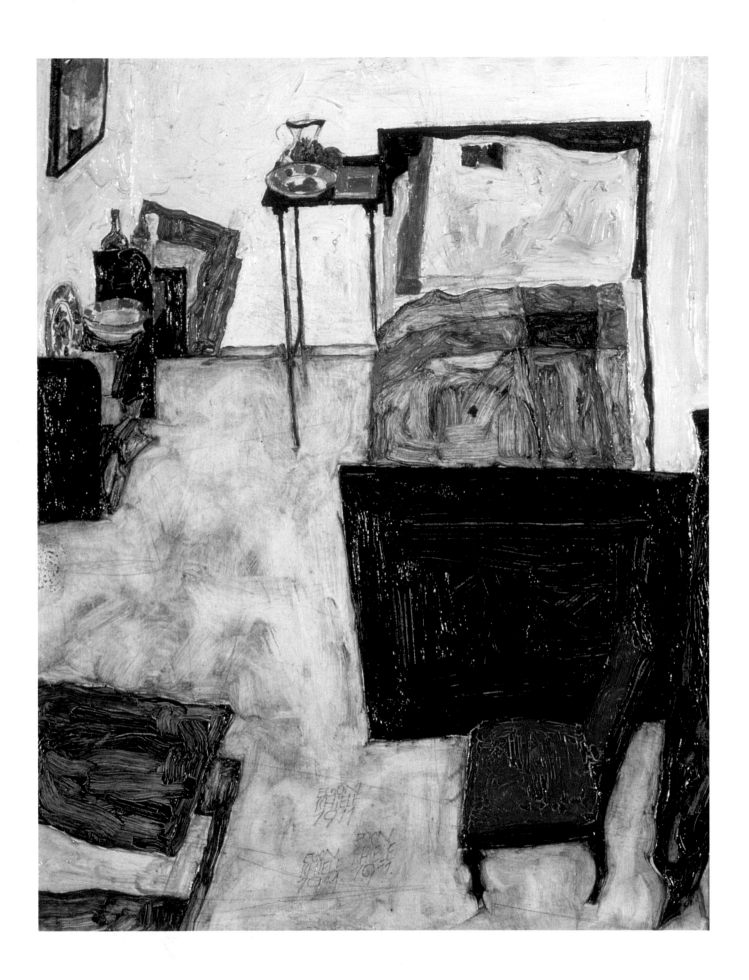

Dead City III

1911. Oil and gouache on wood, 37.1 x 19.9 cm. Rudolf Leopold Collection, Vienna

Krumau, or the 'dead city' as Schiele referred to it, was his mother's birthplace, and served in 1911 as a kind of romantic retreat from Vienna. Given the affection Schiele seems to have felt for the place, it is perhaps peculiar that he should name it as he did. In May 1911, he and his new model and mistress, Valerie Neuzil (Wally), moved there. In the short time that he stayed in the town, he made a series of paintings of it. The present piece is a variation on a watercolour of 1910, and is the town as seen from the Schlossberg. A deep cobalt blue, which in places turns to black and represents the River Moldau, surrounds the buildings, which are themselves predominantly dark browns and greens, accentuated by areas of ghostly greys and near whites. Moving from the front edge of the first buildings to approximately half way up, the buildings are painted in a fairly conventional manner, except for their colours. However, as we move further into the town, particularly toward the left side, the colours come to dominate at the expense of illusory space; to the right, buildings dissolve into more abstract, geometricized forms which deny any sense of human space. This abstract quality is developed further in structurally complex works such as *Krumau Town Crescent I* (Fig. 24), which emphasize the geometric form of the buildings, extended across the surface of the canvas in a manner reminiscent of early Cubist townscapes. *Dead City III's* oppressive tonal qualities and its abstract denial of space, as well as the absence of any trace of human life – such as the laundry hung out to dry that we find in other townscapes – impose upon the viewer a sense of lifeless rigidity which responds to the work's title.

Fig. 24
Krumau Town Crescent I
(The Small City V)
1915–16. Oil on canvas,
109.7 x 140 cm.
Israel Museum, Jerusalem

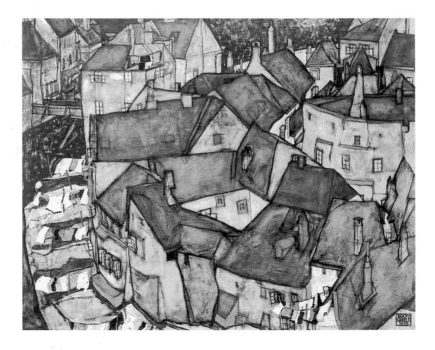

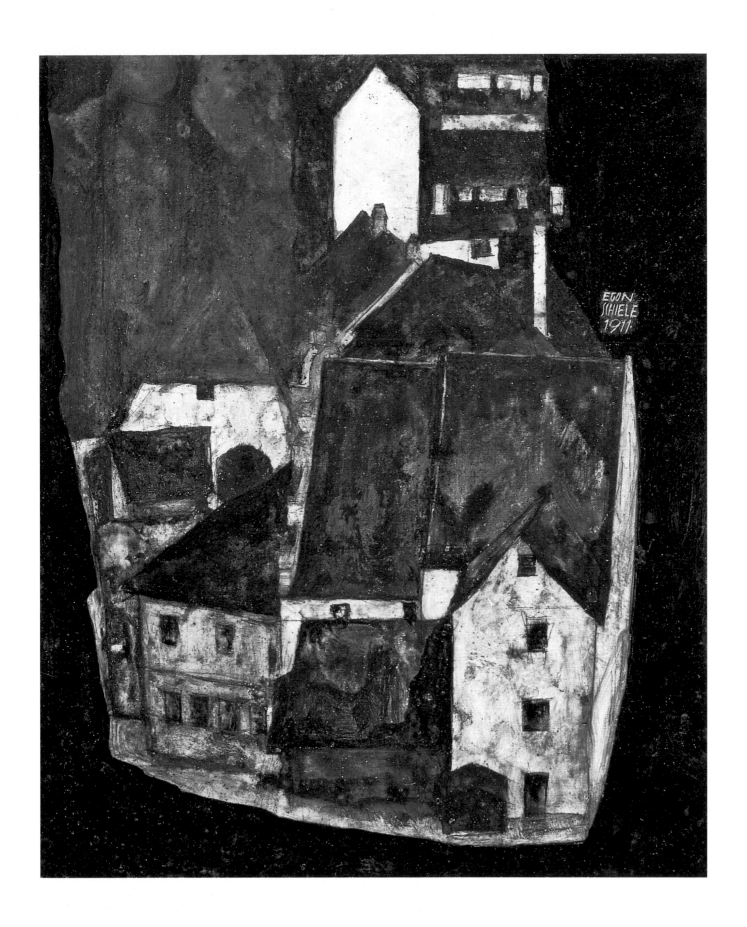

19　Self-Portrait with Black Clay Vase and
Spread Fingers

1911. Oil on canvas, 27.5 x 34 cm. Historisches Museum der Stadt Wien, Vienna

Another of Schiele's Bretterl, this painting is striking both for its luminosity and for its tone and colour contrasts. A further contrast is between the amorphous and organic form on the cloth on the table behind Schiele, with its geometric, Werkstätte-like patterns, and the similar (though perhaps pictorial) shapes at the rear left. Yet the most extraordinary feature of the painting is that it amounts to yet another, though somewhat unusual, double self-portrait. The clay vase, seen behind Schiele's head and to the right, bears the almost silhouette profile of a face. Schiele represents himself as a two-faced Janus, facing forwards and backwards at the same time. The alter-ego to the rear signifies the artist's natural urges, an association reinforced by the foliage (a branch of his much-favoured winter cherry) which touches the head from the right; the more realistic face is a product of culture, the artist's persona which is associated with the geometricized patterns which touch his head to the left and the machine-made ones which touch his body to the right. The exaggerated gesture of the hand, suggesting some great incision to the chest, the twisted, uncomfortable posture which obscures one shoulder, and the wearisome facial expression all add up to the spurned martyr who sacrifices social acceptance for some greater, hidden truth.

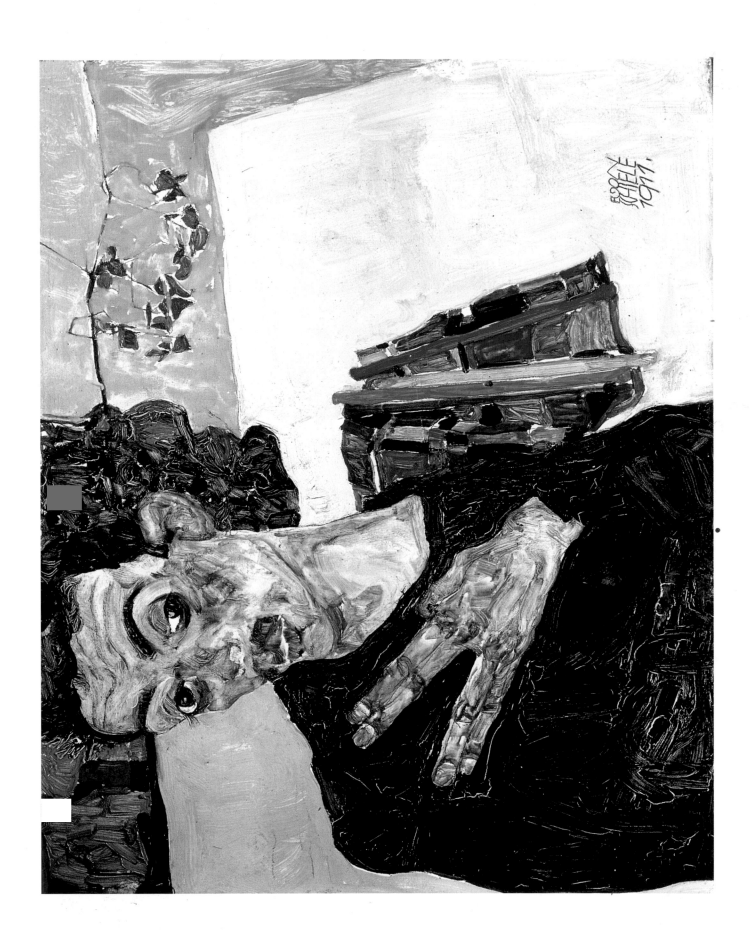

Two Girls (Lovers)

1911. Gouache, watercolour and pencil on paper, 48.3 x 30.5 cm.
Private collection

The theme of lesbianism, suggested here in *Two Girls (Lovers)*, is one that would persist throughout Schiele's work from 1911 on. In this early piece, the two figures are passive, eyes closed in sleep; by 1915, in *Two Girls, Lying Entwined* (Fig. 25), the artist complicates the affair. In place of the familiar self/other, masculine/feminine distinctions, there is here a particular variation upon the seer/non-seer (blind) theme, manifest in the lifelike face of the nude model and the blind, mask-like face of the clothed figure. This latter, with its doll-like face and limp limbs, seems completely to lack personality; its eyes – so often exploited for their expressive quality – are represented as little more than hollow, button-like pupils. In painting *Mother with Two Children III* (Plate 37), also begun in 1915, Schiele substituted a Japanese doll which he kept in his studio for the child (Schiele's nephew) when he was unavailable; whether the female model's face relates to the same doll or not, it is clear some such source is exploited. A further point of comparison is with the life-sized doll of Alma Mahler which Kokoschka had made for him following the end of their relationship, and with which he painted a self-portrait a few years later.

In a peculiar way, this later painting is something of a synthesis of the two types discussed in relation to *Portrait of the Artist's Wife, Standing* (Plate 35), in which the passive, doll-like Edith figure comes into contact with its active counterpart, the Adele figure.

Fig. 25
Two Girls, Lying
Entwined
1915. Gouache and pencil
on paper, 32.8 x 49.7 cm.
Graphische Sammlung
Albertina, Vienna

A Tree in Late Autumn

1911. Oil on wood, 42 x 33.6 cm. Rudolf Leopold Collection, Vienna

In 1910, Schiele painted one oil in which trees were the central focus; in 1911, there were three, and in 1912, no fewer than six. Foliage on the trees is at best sparse, and in most cases absent as the artist chooses to paint them either in autumn or winter. In poems and letters Schiele expressed his fascination with autumn as symbolizing the decay which forms part of life. It is not merely the decay and death of the tree itself that engross the artist, but their relation to human life. In a letter to Franz Hauer in August of 1913, Schiele wrote how in the physical movements of mountains, water, trees and flowers, 'everywhere one is reminded of similar movements in the human body, of similar motions of joy and suffering in plants.' In the same letter he goes on to describe the profound emotion stirred by an autumnal tree found in summer: 'It is this melancholy I wish to paint.' In *Autumn Trees* (Fig. 26), which has been associated, through Schiele's painting *Calvary* (1911, private collection), with the three crosses on Golgotha, this sense of melancholy is evident. In this respect, however, *A Tree in Late Autumn* is exceptional. The similarity of the tree to a human form, waving arms and kicking a leg in the air, is unmistakable, and conforms wholly to the anthropomorphic understanding of nature Schiele describes in the letter to Hauer. But the image is far from expressing the melancholy of so many of Schiele's trees and landscapes; here, nature is filled with energy, whether of joy or of pain and suffering.

Fig. 26
Autumn Trees
1911. Oil on canvas,
79.5 x 80 cm.
Private collection

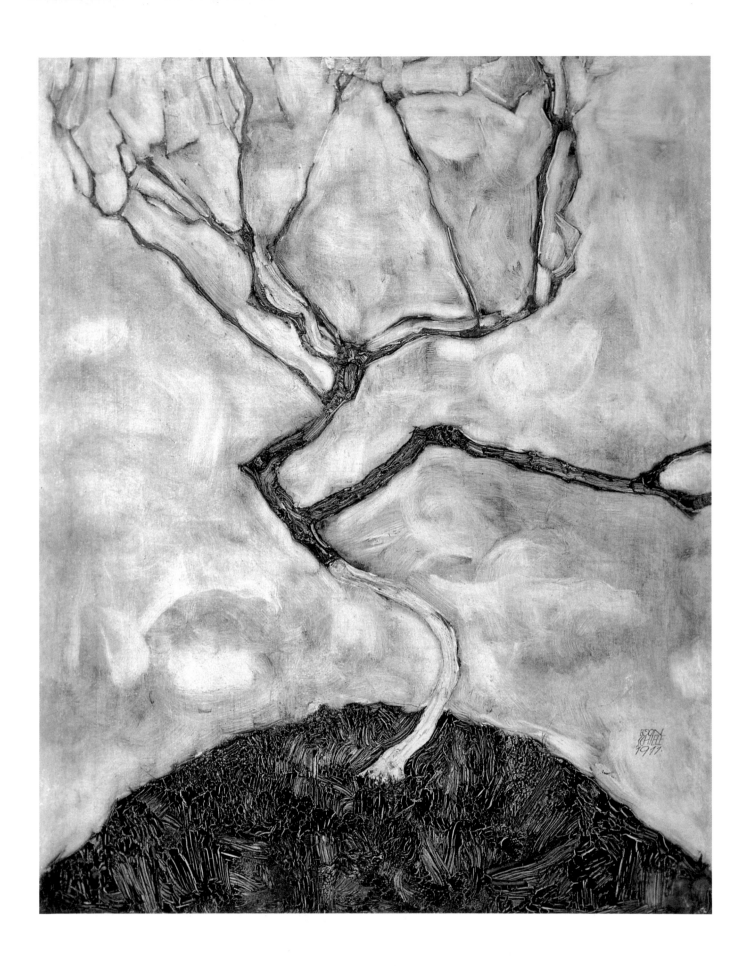

The Hermits

1912. Oil on canvas, 181 x 181 cm. Rudolf Leopold Collection, Vienna

This is Schiele's largest painting to date, thought to have been started in the latter half of 1911 and completed in early 1912. Partly because of its size, it was never sold during his lifetime. Developing the more spiritual aspects of the *Self-Seers* series, Schiele began to produce works with religious-sounding titles, evoking the image of himself as a monk-like holy man. This figure's dress recalls Gustav Klimt's flowing robes, which set him apart as a member of an artistic brotherhood, and which Schiele also wore in emulation of his mentor. There are also echoes of the many symbolist paintings by Ferdinand Hodler in which cloaked figures are repeated in a symbolic evocation of the spiritual. Of the two figures represented, Schiele wrote: 'They have sprung up here by themselves, an organic extension of the earth... I see the two figures as resembling a cloud of dust, like the earth, which rises of itself, only to collapse in exhaustion.' This mysterious sense that the figures are an ephemeral manifestation of the earth would seem to deny any more empirical reading, yet the figure to the left clearly represents Schiele himself, while to the right is thought to stand Klimt. Developing the quasi-religious/ spiritual theme at an autobiographical level, Schiele extends the theme of artist as outsider to that of artist as martyr by including a crown of thorns about his own head. He stares defiantly from the picture not only as martyr to an artistic and spiritual cause, but as protector of the new traditions of the avant-garde. Though still very much the most successful painter in Vienna, Klimt was already coming to be seen by some as facile and old-fashioned; Schiele, who had as yet in no real sense come to be accepted by society, stands with his body covering that of the now exhausted-looking Klimt, whose work had once provoked the most vicious invective of the critics.

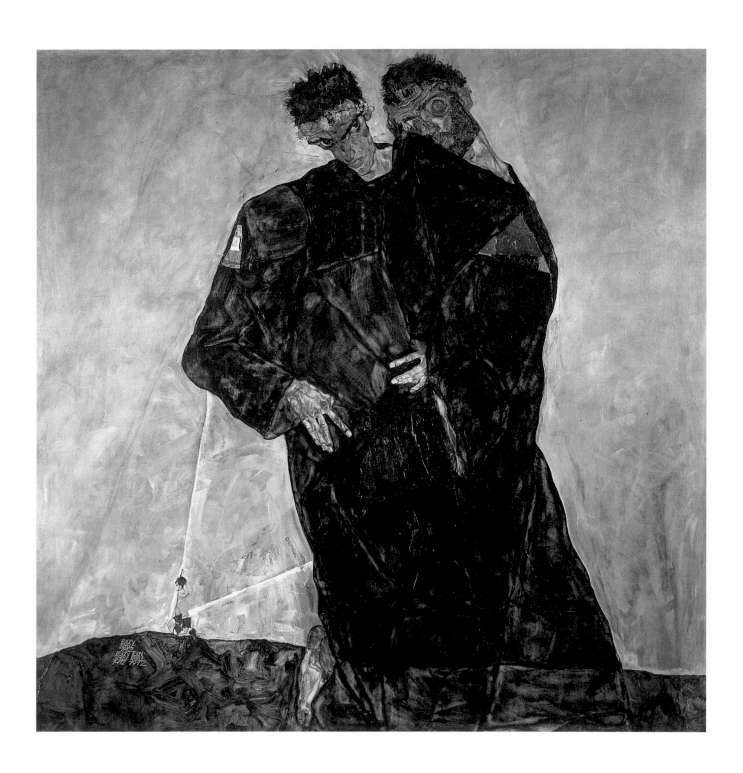

The Single Orange was the Only Light

1912. Gouache, watercolour and pencil on paper, 31.9 x 48 cm. Graphische Sammlung Albertina, Vienna

On 16 April 1912, three days after his arrest and imprisonment in Neulengbach, Schiele received a limited range of drawing materials. In the diary he is supposed to have written of the period in prison, the entry for 19 April reads: 'I have painted the cot in my cell. In the middle of the dirty grey of the blankets a glowing orange, which Wally brought me, as the single shining light in the room. The little colourful spot did me unspeakable good.' Whether the words are Schiele's or Roessler's, the sense of liberation brought by the representation of a strongly coloured fruit, in the setting of the dreary prison cell, is strong. The interior is drawn in great detail, down to the graffiti on the wooden door and the very lightly drawn lines alongside the bed which may indicate a landscape the artist drew with his own spittle before proper materials were available. Beneath the signature, top right, the inscription written across the surface of the drawing now serves as the work's title; the letter 'G' which precedes the date stands for *Gefängnis* (prison).

Self-Portrait as Prisoner

1912. Watercolour and pencil on paper, 48.2 x 31.8 cm.
Graphische Sammlung Albertina, Vienna

Begun on 23 April, the series of four self-portraits which Schiele did in just three days while in prison perhaps most obviously express the sense of despair which imprisonment created. The one illustrated here was painted on Thursday 25 April (the 'D' signifies Donnerstag) and bears the inscription, 'For art and for my loved ones I will gladly persevere.' Text and image are overstated and self-pitying. It is a highly 'expressive' work, a product of the artist's memory and imagination; the prison self-portraits, we are told, are the only ones he made without the mirror which was such an important part of his studio furniture. Almost reptilian in appearance, his form is twisted in a manner which reinforces the pained, almost horrified facial expression. The hands, which along with the face are so important in Schiele's portraits, are skeletal in appearance, clasping claw-like at the blanket, and sending creases like great talons across the surface. Yet the image is one of complete helplessness and abandonment. In these works the self-assertive, challenging manner of self-portraits executed before imprisonment is surrendered in favour of the helpless, persecuted victim.

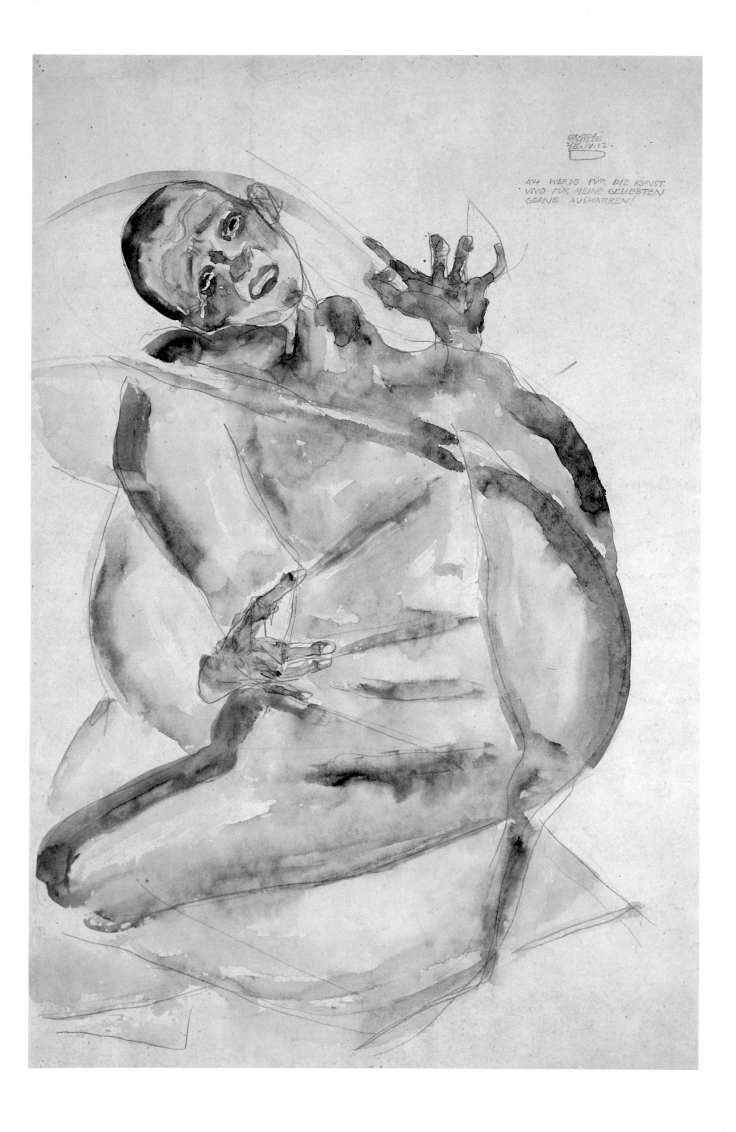

25 Cardinal and Nun (Caress)

1912. Oil on canvas, 69.8 x 80.1 cm. Rudolf Leopold Collection, Vienna

The diary which Schiele is supposed to have composed in prison questions the thought that he could corrupt the minds of children: 'Have adults forgotten how corrupted, that is, incited and aroused by the sex impulse, they themselves were as children?' The present painting attempts not to uncover this sexual dimension to childhood, to which so many of Schiele's drawings of children had been devoted, but in an equally contentious way to make manifest a sexual – and thus potentially hypocritical – dimension to the Church. Though the theme has a long history, its treatment at Schiele's hands emphasizes the sordidness of the affair, the sense of lust on the part of the cardinal (Schiele himself), and of guilt and shock at being caught *in flagrante* in the gaze of the nun (Wally, his model and lover). The large areas of colour which, together with their bold geometric forms, dominate the composition are not merely formal devices; in particular, it has been suggested that they articulate in more subtle form Schiele's assault on the Church, the black of Wally's cloak being traditionally associated with the Catholic Church, the red of Schiele's signifying opposition to the clergy and support for the socialist ideal, a colour symbolism he had invoked once before in 1911 when trying to describe the opposition he and Wally had met during their brief stay in Krumau.

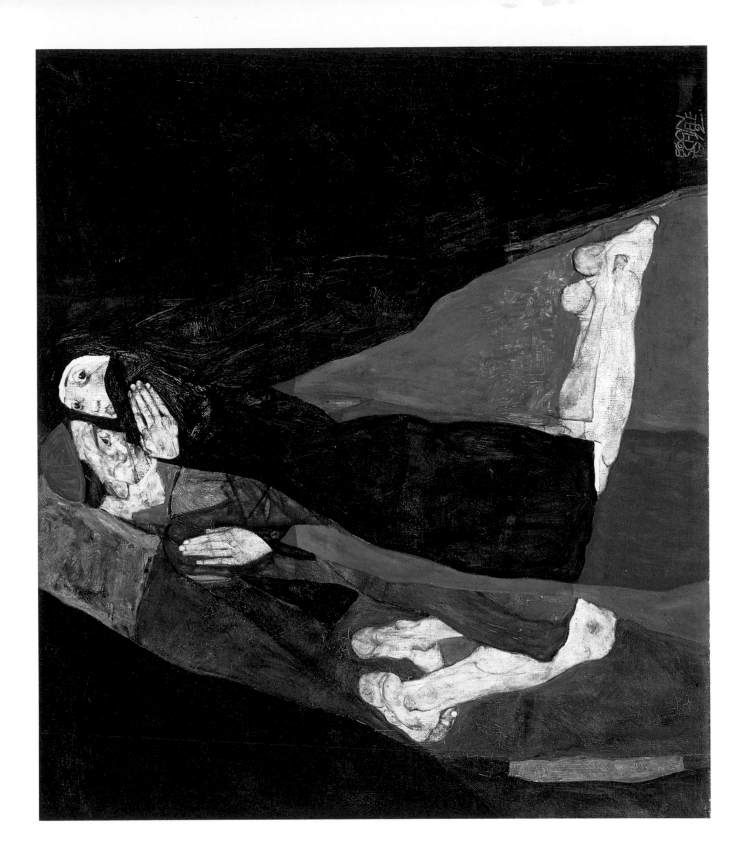

Portrait of Erich Lederer

1912. Oil and gouache on canvas, 139 x 55 cm. Öffentliche Kunstsammlung, Basle

It was through Gustav Klimt that Schiele met the wealthy industrialist and important patron of Klimt, August Lederer. His son, Erich, was also an avid collector of art, and when his grandmother presented him with a winning lottery ticket, he decided to add to his collection in the form, among other things, of a Schiele portrait. Thus on 21 December 1912, Schiele arrived at the Lederer estate in Györ, Hungary, to begin working immediately on the commission. The formal pose, the subject's austere expression (described by Schiele as 'aristocratic') and composed stance are a far cry from the casual, almost squalid pictures of youths he had painted earlier that year and which had contributed to his period of imprisonment. In this and other portraits after imprisonment the character of the sitter becomes less subject to the artist's own psyche as Schiele, it seems, enters into a renewed relationship with, and respect for, his environment. Yet that environment is no less subject to the artist's manipulation; in place of the expressionist distortion of earlier works, we note a manipulation of the faceted, geometricized surface first encountered in works such as the *Dead City III* (Plate 18). From the colourful Werkstätte rug to the folds in Erich's clothes, areas of the canvas become a complex surface of tilted facets which now find an echo in the double 'V' of the sitter's left hand. Schiele executed around twenty colour sketches for the portrait, some of them depicting Erich himself drawing; later, he would take lessons from Schiele, as well as becoming a loyal friend and patron. During the following years Schiele would visit the family often at their Vienna residence, committing to paper many important drawings of the young Erich.

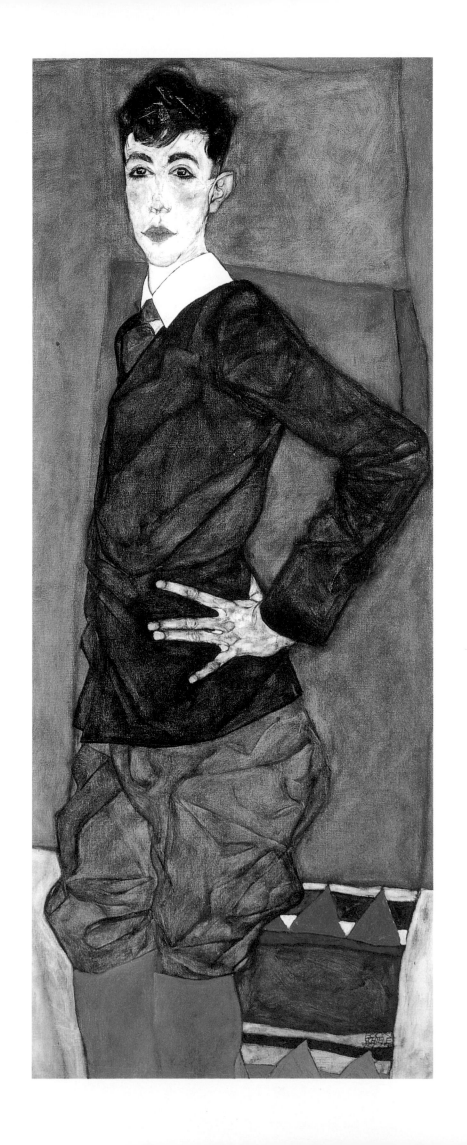

The Bridge

1913. Oil on canvas, 89.7 x 90 cm. Private collection

In a letter written to Arthur Roessler from Györ in Hungary on Christmas Eve, 1912, Schiele describes how in wandering through the district he had found an old wooden bridge, 'quite Asiatic, Chinese-like'. As a subject, this bridge is exceptional in the artist's *œuvre*; in its manner of representation, it is less so. Schiele was interested in Chinese and Japanese art, which he collected, and its influence can be clearly seen in this work. In a manner reminiscent of certain Japanese prints, the painting takes the landscape motif and, through a process of exclusions, reduces it to a limited number of essential forms and qualities. Most important is the clear emphasis on vertical and horizontal structures, with a limited number of diagonals to support the railings either side of the road, and the colourful decoration on the boat. The rest – the river and the far shore – becomes mere surface which accentuates the serenity of the scene. This is an untroubled image, in which the formal elements of the painting are allowed to stand for little other than themselves; in this regard, *The Bridge* is truly exceptional among Schiele's works to date.

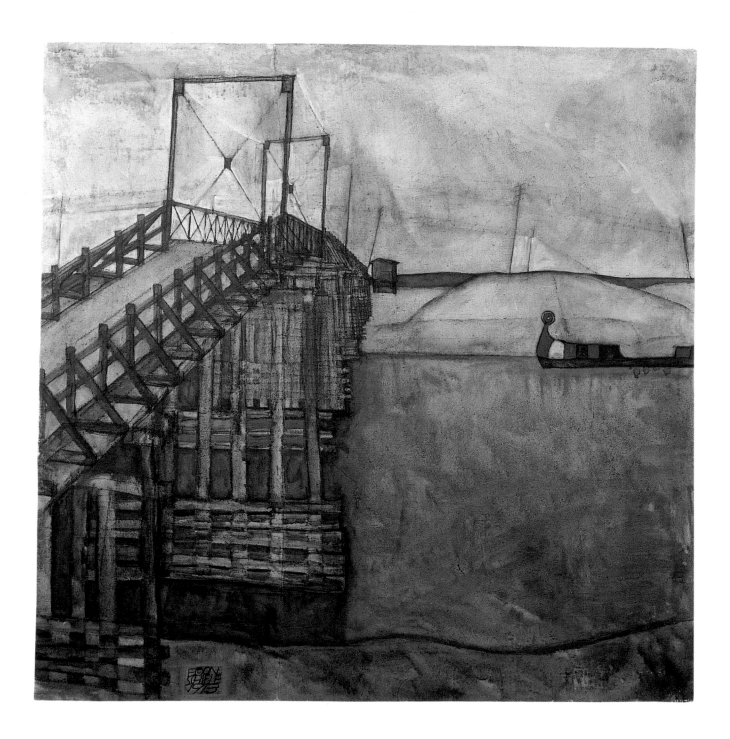

28 Double Portrait (Chief Inspector Heinrich Benesch and his Son Otto)

1913. Oil on canvas, 121 x 131 cm.
Neue Galerie der Stadt Linz/Wolfgang-Gurlitt-Museum, Linz

It was in 1908 that Heinrich Benesch, a railway inspector, met Schiele; in 1910, Benesch began collecting his work and became one of the artist's principal patrons and a close personal friend. This work is perhaps the most important portrait the artist produced of a patron, a double portrait of Heinrich and his seventeen-year-old son, Otto, who in 1915 published a long forward in the catalogue for the exhibition of Schiele's work at the Galerie Arnot (see Plate 30), and who would later go on to become an important art historian and director of the Albertina. For the first time, Schiele painted a real (as opposed to allegorical) father and son; yet, while the physical likeness of Heinrich and Otto is apparent, Schiele manages to articulate in no uncertain form a universal conflict between father and son. On the brink of adulthood, Otto has not yet achieved that worldly wisdom suggested by his father's watchful gaze across his left shoulder at us; the great bulk of his body, the powerful outstretched arm (also painted with the hand in his left pocket, as though the barrier were erected as we watch) protect the boy from us, yet simultaneously hold the boy from moving from the space his father creates. Later, Otto's wife would write in relation to the work that 'Heinrich Benesh liked to dominate. ... Schiele recognized *the gaze into the world of the mind* beyond all external barriers already in the boy... and he expressed it in the portrait.'

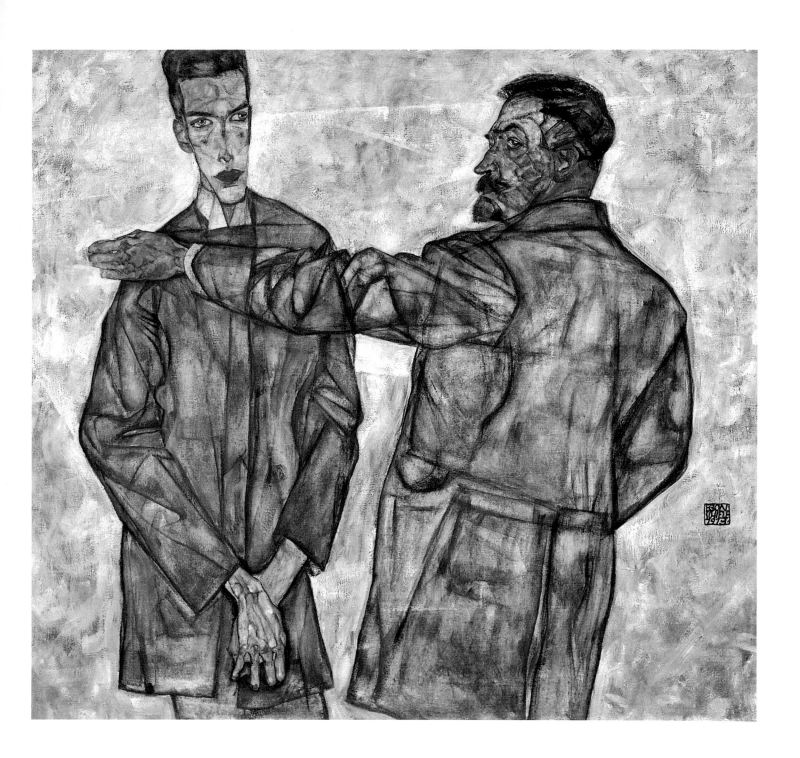

Holy Family

1913. Gouache and pencil on parchment-like paper, 47 x 36.5 cm.
Private collection

This work brings together a number of concerns that were important to
Schiele. At a formal level, areas of the painting are striking for the abstract,
almost geometricized pattern to which form is reduced. In particular, the
area below the man's chin and to the right of the woman's head, with the
assistance of the now familiar spread fingers, is presented as a strongly
coloured area of fractured triangles and tetragons. This area is clearly
echoed in the small, similarly coloured portion of the paper at bottom left.
These parts of the picture contrast with large areas of apparently less
carefully applied dark, almost earthy colour. In this regard, the work is a
development from those produced since 1911 in which the surface of
things represented, indeed, the surface of the canvas itself, is increasingly
reduced to a geometricized pattern. In terms of what is represented, *Holy
Family* relates in important ways to the *Dead Mother* works. This is most
obvious in the curious space occupied by the baby. In *Dead Mother I*
(Rudolf Leopold Collection, Vienna), the position of both space and child
suggests that the child is wrapped in blankets, close to the mother's face;
by *Dead Mother II* (Fig. 22), the space has shifted down the mother's body
and comes to resemble more fully some window to the world from the
womb through which the child peers, amazed. In the present image, that
look of amazement persists as the child, gazing from its mother's body, is
protected behind a veil of orange, reminiscent of transparent cloth. The
picture is altogether less pessimistic than the *Dead Mother* works, not least
because the mother in no sense appears dead, nor suggestive of mortality.
Finally, the work offers an alternative to *Cardinal and Nun* (Plate 25) of
1912; Egon's and Wally's role is no longer sacrilegious as the sexuality
implied in the earlier work is sanctified by the presence of the child.

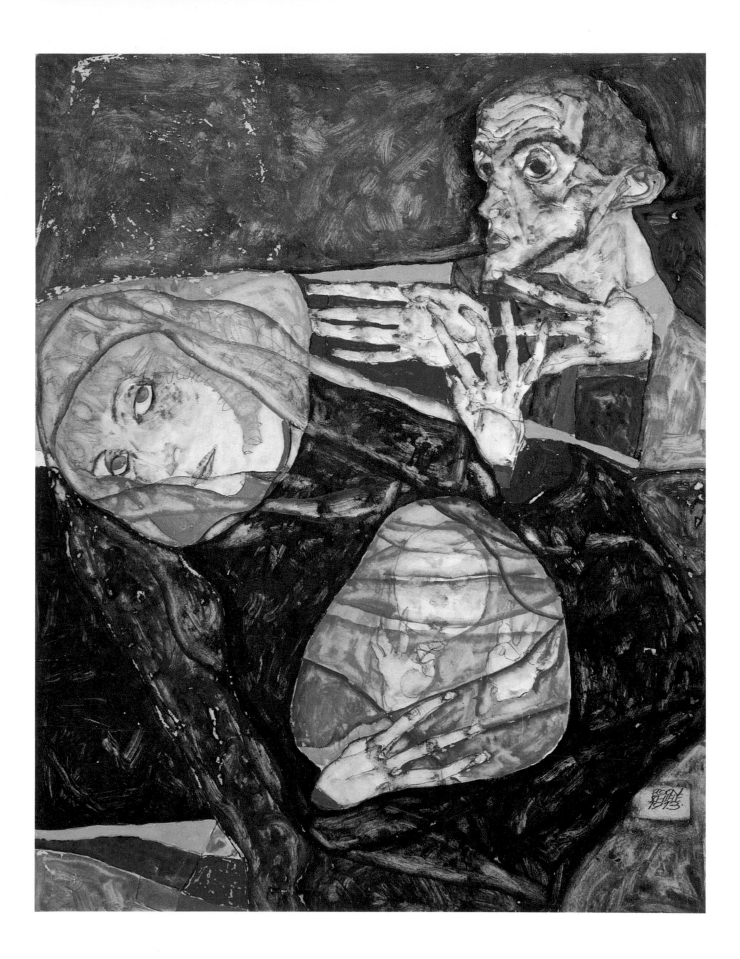

Self-Portrait as St Sebastian

1914. Poster in gouache, black crayon and ink on cardboard, 67 x 50 cm.
Historisches Museum der Stadt Wien, Vienna

This poster advertises an exhibition of Egon Schiele's work at the Galerie
Arnot in January 1915. The show consisted of 16 oils and a number of
watercolours and drawings, and seems to have been a significant success,
with positive reviews in which even those most opposed to Schiele made
concessions to the artist's ability. In the poster, that sense of artistic,
almost spiritual martyrdom present in *The Hermits* (Plate 22) is now
extended in an obvious way. Again, the image is a conventional one, but
as so often, Schiele renders the motif autobiographical by making of it a
self-portrait. The use of such gruesome images in advertising posters had,
by 1915, become something of a commonplace among the Viennese
avant-garde; in particular, Oskar Kokoschka depicted brutal violence
between a man and woman on the now famous 1908 poster advertising his
play *Murderer, Hope of Women*, and in Max Oppenheimer's poster for his
exhibition of 1911, the distorted figure fingers a wound in its chest from
which blood flows copiously. But apart from conforming to a trend, this
brutal martyrdom, strengthened in the poster through use of colour,
reflects the self-pity we have seen in certain of the phrases Schiele had
written on the prison pieces (Plate 24); the artist, like many of the writers
who have written on Schiele since, came to realize that, if nurtured
carefully, that sense of marginalization, even persecution, which he had
experienced, could be turned to his advantage as he established himself as
a member of a radical avant-garde.

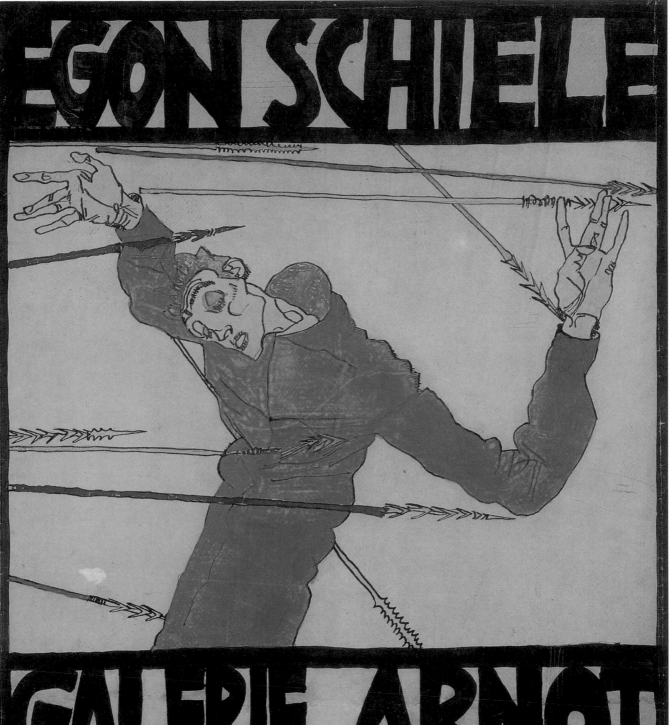

31

Reclining Female Nude with Legs Spread Apart

1914. Gouache and pencil on paper, 30.4 x 47.2 cm.
Graphische Sammlung Albertina, Vienna

In so many of Schiele's drawings and paintings of female nudes, it is raw sexuality which seems to be the subject of the work, with a certain attention to the psychological state of the sitter. In the present piece, it is the former which clearly dominates: here, neither line nor the vacuous background seek to articulate anything of the subject's psyche (except, perhaps, a sense of boredom and vacancy). The subject is merely a sexual object, its lips and nipples highlighted in bright orange, its legs spread apart to expose its sex. Torso, arms and legs serve the purpose of leading the male gaze from one erogenous zone to another, and very little else. The subject is Valerie Neuzil (Wally), who remained Schiele's mistress until the artist's marriage to Edith Harms in 1915.

Houses by the River II (The Old City II)

1914. Oil on canvas, 100 x 120.5 cm. Thyssen-Bornemisza Collection, Madrid

The central feature of this painting is the Jodokus Church on the Moldau River in Krumau, the same town depicted in the *Dead City* works. As in *Dead City III* (Plate 18), the flat, geometric arrangement of buildings denies human space, and there is no trace of life – in marked contrast to a later picture based on precisely the same view (though from a shorter distance), *House with Drying Laundry* (1917, private collection), in which drying clothes serve to suggest not only movement, but the presence of living people. Yet, in stark contrast to the *Dead City* piece, the painting is vibrant with life. The anthropomorphic quality of the buildings is unmistakable as the windows gaze, like eyes, down upon and across the river to engage the viewer. To achieve such animation, Schiele deviated significantly from the way things actually were, as may be seen by comparing the work with extant photographs of the site. In particular, the steep roof to the church has been extended, becoming forehead-like, its small windows compressed and accentuated by small blocks of white, suggestive of the whites of eyes surrounding a pupil; to the left of the church, the number of windows is reduced so as not to confuse the reference to human form.

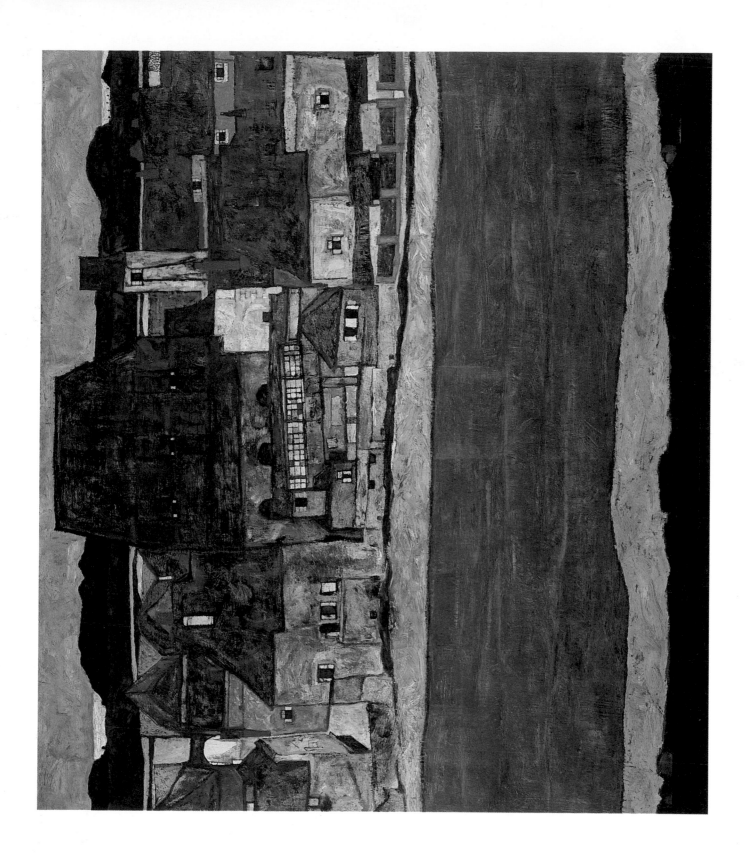

1915. Oil on canvas, 100 x 120 cm. Private collection

Fig. 27
Woodland Prayer
From a sketchbook, pencil,
14 x 8.5 cm.
Graphische Sammlung,
Albertina, Vienna

This work's extraordinary subject – a devotional shrine in a woodland setting – is difficult to decipher, let alone interpret. Toward the centre is a central shrine containing, among a set of images, a Crucifixion. To the left is a second shrine with a second Crucifixion, and to the right a third, this time with a rounded rather than arched gable. Throughout the work are scattered paintings whose subjects range from the Crucifixion to Madonna with Child and the Last Supper. That these paintings should be associated with such shrines is not unusual; that those images should be scattered in such numbers and in such a random fashion, that they should throw into confusion our perception of the space they occupy, is unusual. A preparatory study for the work (Fig. 27), in many ways reminiscent of certain drawings by Paul Klee, presents a much more sparsely decorated woodland, its vertical emphasis determined by the trunks of the trees. The format is compressed in the final painting to form a wider image, and the composition gains more horizontal emphasis by the inclusion of heavy beams which run at right-angles to the trunks. These are the cross members of another set of crucifixes, upon which we see, through the trees, three figures: the head and chest of the central figure, two hands of the figure to the left, and a shoulder and two hands of the figure on the right. Schiele recalls in the work not only his painting *Calvary* (1911, private collection) with its obvious reference to Golgotha, but also *Autumn Trees* (Fig. 26). Rather than a woodland which contains a religious shrine, Schiele presents a woodland which is a shrine.

Death and the Maiden

1915. Oil on canvas, 150 x 180 cm. Österreichische Galerie, Vienna

Fig. 28
Transfiguration
(The Blind II)
1915. Oil on canvas,
200 x 172 cm.
Rudolf Leopold
Collection, Vienna

Fig. 29
Oskar Kokoschka
The Tempest
1914. Oil on canvas,
181 x 220 cm.
Kunstmuseum, Basle

When Schiele finally decided to marry Edith Harms, his ever faithful model and lover Valerie Neuzil (Wally) was still very much part of his life. Not surprisingly, Edith insisted she be dealt with; Schiele's solution was to present Wally, in a meeting in a café, with a written proposal couched in pseudo-legal language that while he could not be with her the rest of the year, they should in future be committed to spend summers together, without the company of Edith. Astonished, Wally refused the offer and departed never to return to Egon. Though there can be no positive identification of the girl in the present painting, it is assumed to be Wally, and it is against the background of their separation that the work may be understood. The figures cling to each other, his face horrified, hers resigned. In retrospect, it seems prophetic that the figure to the left (clearly Schiele), to which Wally clings, is Death – in 1917, Wally died of scarlet fever in Dalmatia. But for Schiele this is more a figure of destruction, a confession of his guilt at the pain he caused his most loyal friend. A direct precedent for the work is Oskar Kokoschka's *Tempest* of 1914 (Fig. 29), to which it is linked both stylistically and compositionally. However, the tone is quite different: in the earlier work, the tempest rages around the figures of Kokoschka and Alma Mahler, who appear to be relatively secure at the centre of things; the apparent stillness in Schiele's work belies the most profound emotional turmoil.

The awkward pose of the two figures is taken a stage further in the double self-portrait *Transfiguration* (Fig. 28), also of 1915: when the female figure to the right is transformed into a second Schiele, it levitates (though neither form changes its posture significantly), reminding us of the weightlessness in his portrait of Friederike Beer (1914, private collection). Each of these three works has a significance quite different from the others, but they are connected, along with two or three other works from 1914–15, by their peculiar perspective – as seen from above – and apparent defiance of gravity.

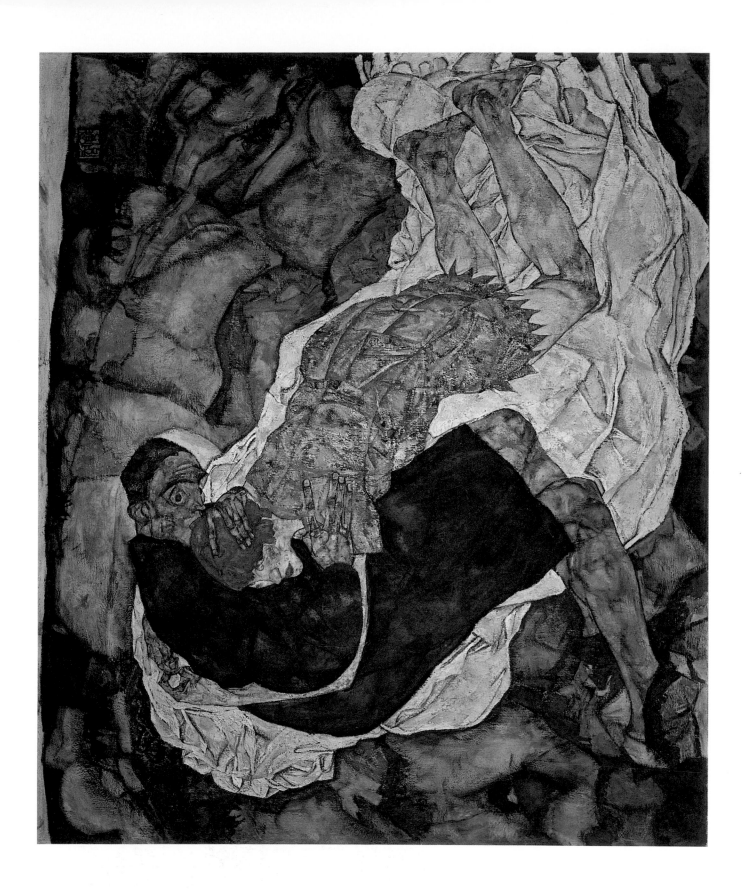

Portrait of the Artist's Wife, Standing (Edith Schiele in Striped Dress)

1915. Oil on canvas, 180 x 110 cm. Haags Gemeentemuseum voor Moderne Kunst, The Hague

When Schiele eventually decided to marry, he wrote to Arthur Roessler that it would not be to Wally; when it came to any such permanent commitment, the artist would forget his anti-bourgeois stance and make sure he married a woman of suitable social standing. Wally, as an artist's model and a woman of no little sexual experience, could hardly conform to the middle-class morality Schiele had hitherto attacked, and now seemed to embrace. Of the two sisters with whom he became variously involved in 1914 and 1915, Edith and Adele Harms, it was Edith that he chose to marry. Despite the protestations of Edith's parents at the prospect of their daughter marrying this financially inept young man who had been imprisoned for exposing minors to pornographic material, the marriage took place on 17 June 1915. *Portrait of the Artist's Wife, Standing (Edith Schiele in Striped Dress)* was begun during August of that year, when Schiele obtained sick leave from his army post. The work is exceptional for the powerlessness of its subject: her simple, almost vacant gaze mirrors the awkwardness of her body which, apparently leaning forward as though to move, scarcely has the confidence to do so. She is vulnerable, passive and apparently innocent – quite the opposite to the abundant sexuality and worldly experience which characterize the artist's representations of Wally. While Schiele may have taken pleasure in this vulnerability, it seems he wasn't about to let go of his fascination for a more aggressive sexuality. As though Edith's alter-ego, Schiele represented Adele on a number of occasions (Fig. 30); the present image contrasts markedly with that of Edith for its sexual suggestiveness. While he produced equally erotic representations of Edith, there is some question as to the nature of the artist's relationship with Adele (we should remember that initially he courted both girls), and the suggestion that she supplemented Edith's own personality in a way that might compensate for the absence of Wally is not unreasonable.

Fig. 30
Reclining Woman
with Green Stockings
1917. Gouache and
black crayon on paper,
29.4 x 46 cm.
Private collection

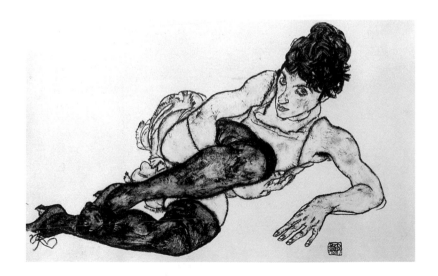

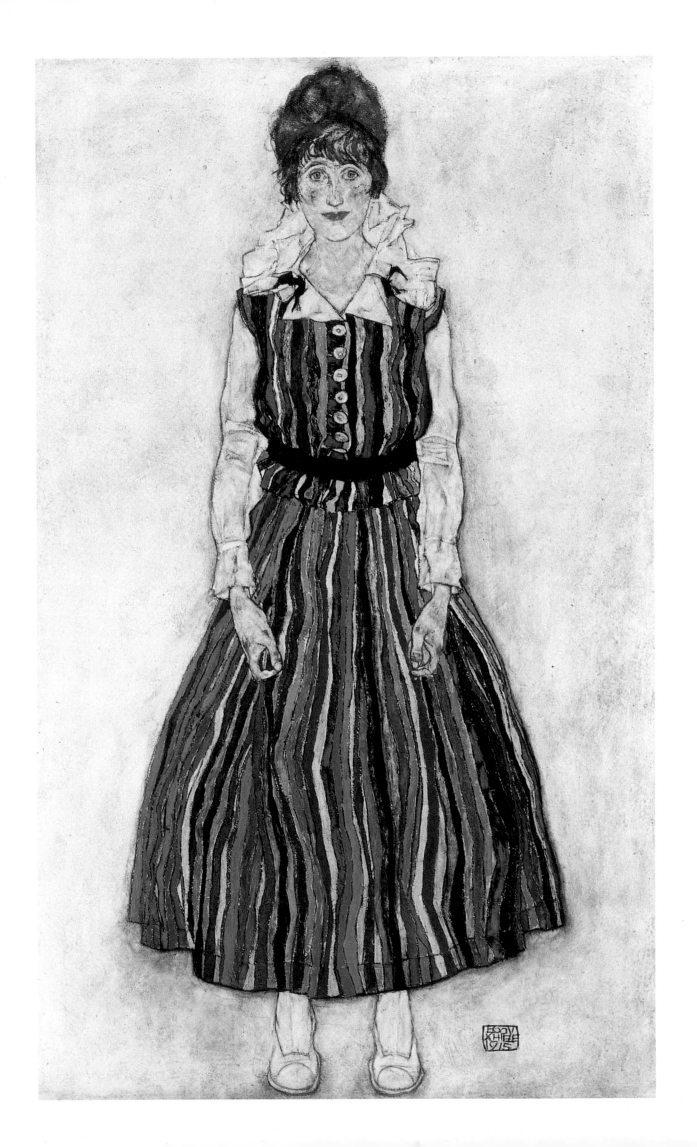

36 Embrace I (Seated Couple)

1915. Gouache and pencil on paper, 52.5 x 41.2 cm. Graphische Sammlung Albertina, Vienna

Representations of heterosexual love number, perhaps surprisingly, relatively few in Schiele's *œuvre*. This image, painted before a mirror, Schiele to the front, Edith embracing him from behind, suggests auto-eroticism on the part of the male. Comparing this work with *Portrait of the Artist's Wife, Standing* (Plate 35), we could read it as a reference to his wife's failure to satisfy his sexual needs; the image is strikingly undynamic, suggesting the absence of that sexual drive which would previously have been so important to such a work. Yet, with this loss, a new theme becomes important. It is now Schiele himself who resembles some near-inanimate doll which, left alone, would fall limp to the floor. His right arm is pushed awkwardly upwards, his torso is curved uncomfortably by Edith's left arm, and it is only the tight embrace of his new wife which holds him upright. The loss of vital, sexual energy, then, is compensated for by a new security, indeed, a new domesticity.

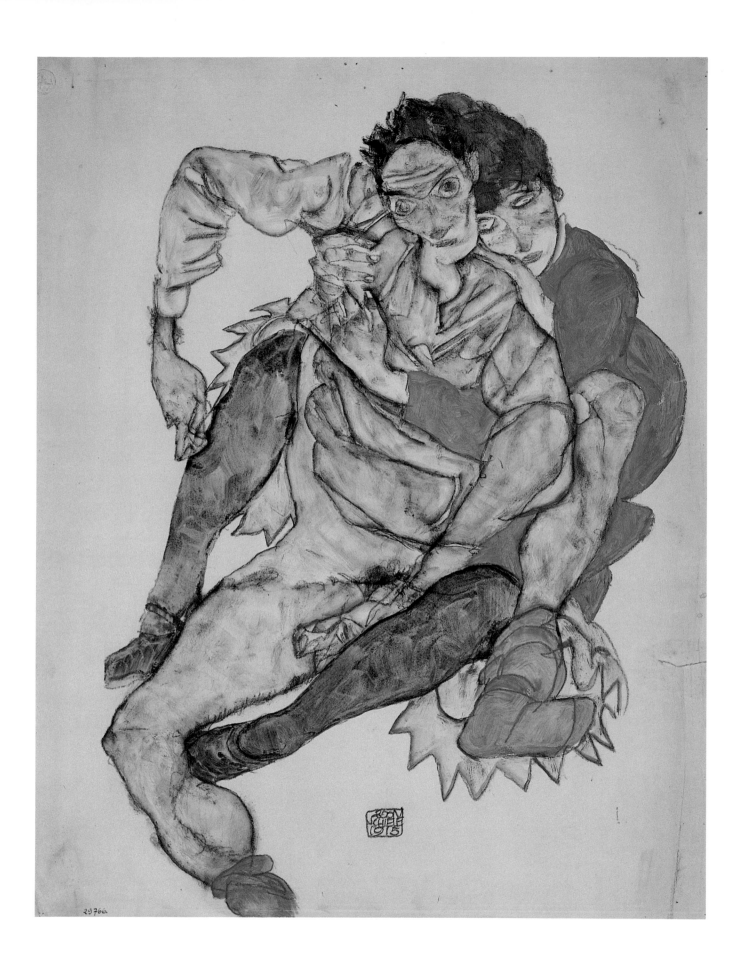

Mother and Two Children III

1917, begun 1915. Oil on canvas, 150 x 158.7 cm. Österreichische Galerie, Vienna

This painting is one of those which Schiele showed at what for him was the enormously successful 49th exhibition of the Vienna Secession. Begun in 1915, though not finished and signed until 1917, it is the last of three on the subject. It contrasts markedly with the negativity of the earlier dead and blind mother works, while earlier versions of the same title, such as *Mother with Two Children II* (Fig. 31), are also rather more pessimistic and thus closer to those other works. Although Schiele used his own nephew, Toni, the son of his sister Gerti and Anton Peschka, as the model for both children, the work's significance lies not with his family as such, but with familiar allegorical themes. The mother figure is clearly not Gerti, but rather a sickly reminder of human mortality in the presence of its counterpart, life. The opposition life/death, which is not dealt with a pessimistic way, is then joined by a number of other oppositions signified by the differences between the two children. In particular, it has been suggested they are associated with introversion (the child to the left, looking toward the group) and extroversion (to the right, looking out toward the viewer), religious (signified by the joined hands) and worldly (open hands), and passive and active. While the work does not altogether escape the negativity of earlier versions, the family group has significant positive connotations, particularly in the context of the new domesticity apparent in certain works following Schiele's marriage.

Fig. 31
Mother with Two
Children II
1915. Oil on canvas,
150 x 160 cm.
Rudolf Leopold
Collection, Vienna

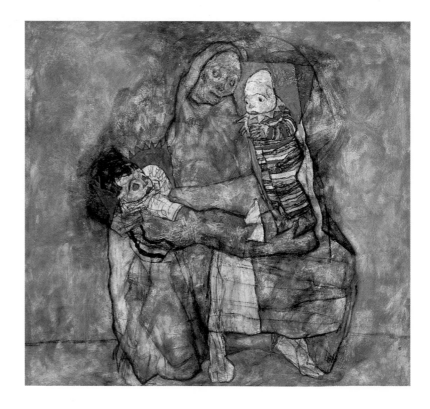

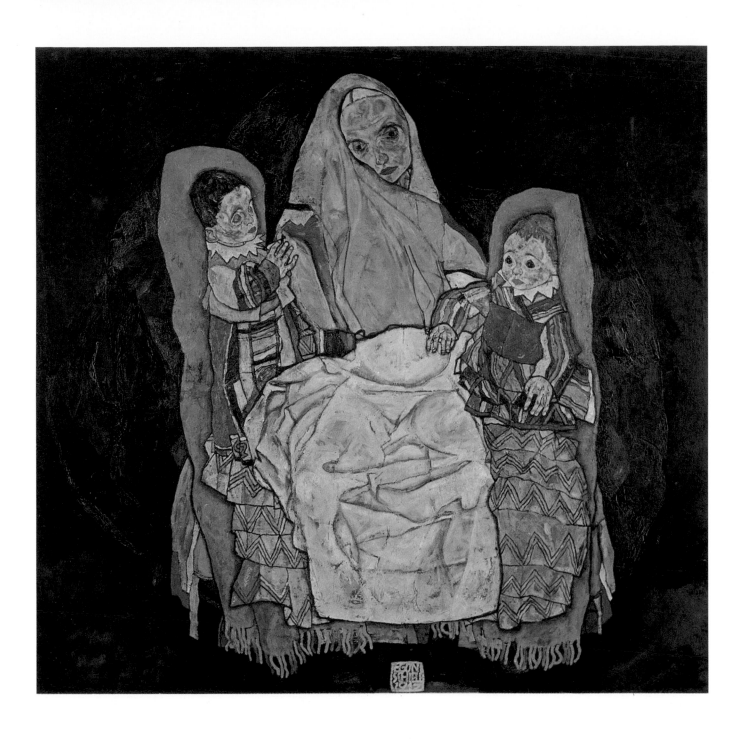

Russian Prisoner of War
(Grigori Kladjishuili)

1916. Gouache and pencil on paper, 48.3 x 30.8 cm. The Art Institute of Chicago

In May 1916 Schiele was posted to Mühling in Lower Austria to work as a clerk in the prison camp for Russian officers. Conditions there were relatively good; Schiele impressed his superior, First Lieutenant Gustav Herrmann, who became quite supportive of the young artist, making available to him an empty storeroom and encouraging him to produce portraits of his own officers. Plate 38, also executed in Mühling, is of a Russian prisoner of war. It is apparent that the Russian soldiers' suffering was of more interest to Schiele than the more formal portraits of his own officers. And this is not merely a continuation of the artist's fascination with despair and negativity: it is a sympathy with not only the plight but the cause of these people. He once admitted to sympathizing much more with 'the other side, with our enemies'; in their countries, he wrote, 'true freedom exists – and there are more thinking people than here.' In so far as Schiele rarely made any such political comment, the statement is exceptional, probably more an immediate result of conversations he had had with Russian prisoners than any more considered political conviction.

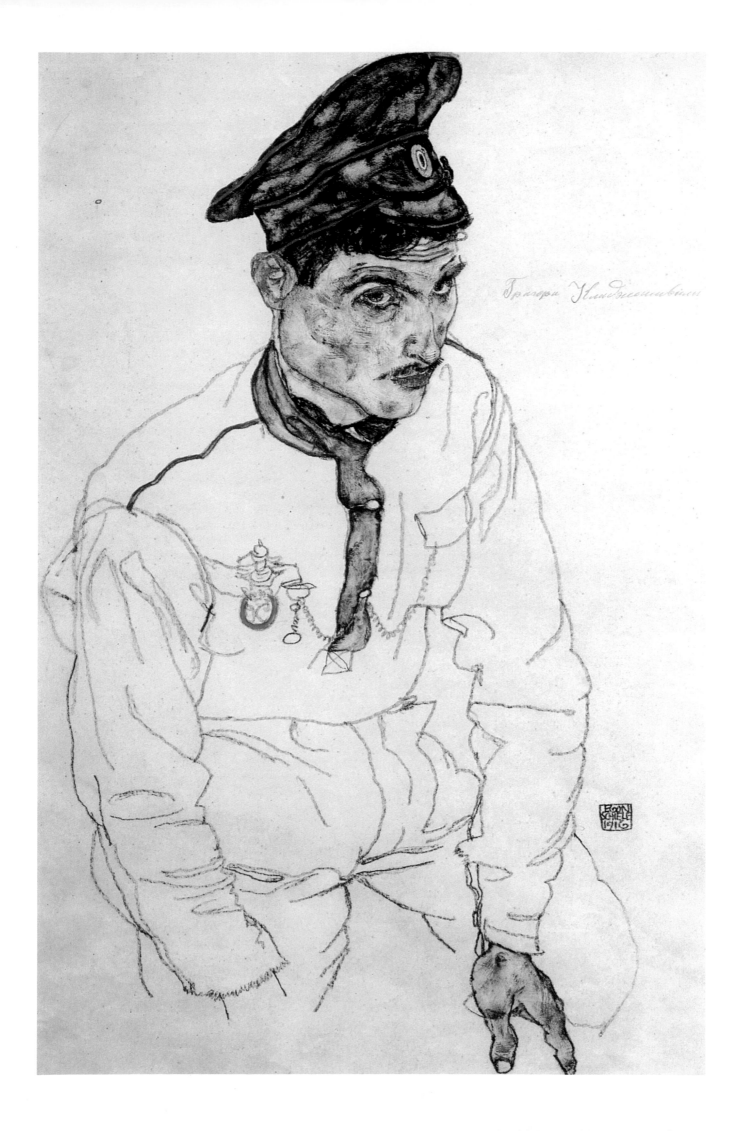

Decaying Mill (Mountain Mill)

1916. Oil on canvas, 110 x 140 cm.
Niederösterreichisches Landesmuseum, Vienna

Schiele began to paint the mill on the river Grosse Erlauf near Mühling on 1 June 1916. It was one of only two oil paintings which he executed while stationed in the town; the second was the now-vanished *Vision of St Hubert*, an extraordinary painting commissioned by his superior, First Lieutenant Hermann. The mill itself, bathed in the summer sun which casts strong shadows on the bright wall, radiates warmth and tranquillity, with its careful rendering of the delicate woodwork and the moss which works its way up from where the structure meets the water. In striking contrast, the lower third of the painting suggests a rush of cold white foam rising almost in a vortex as it forces through the battered sluice, threatening to destroy the man-made form which impedes its passage. The similarity of this treatment of water to that in *Mountain Torrent (Waterfall)* (Fig. 32) is unmistakable. The motif was apparently initially drawn by the artist in the Stubai Valley on a military outing in June 1917, but underwent significant modification and stylization as it was executed in oil. The violent, almost serrated crests of the waves in the painting of the mill recall Schiele's taste for Japanese prints, in particular the sea-scenes of Hokusai.

Fig. 32
Mountain Torrent
(Waterfall)
1918. Oil on canvas,
110.2 x 140.5 cm.
Private collection

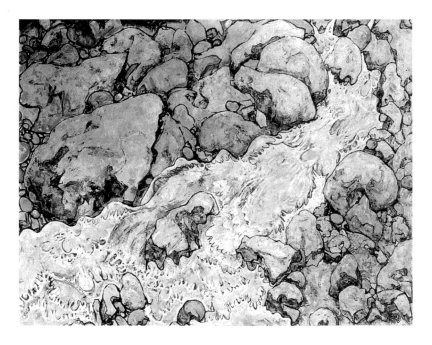

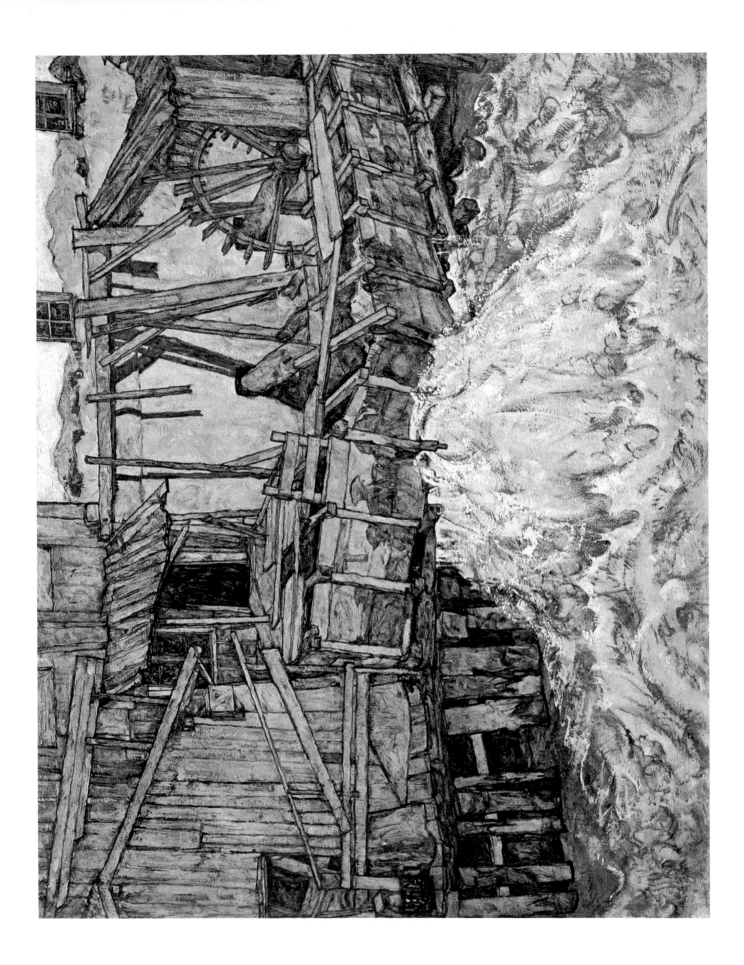

Self-Portrait with Checkered Shirt

1917. Gouache, watercolour and black crayon on paper, 45.5 x 29.5 cm.
Private collection

In a work such as *Self-Portrait with Checkered Shirt* the importance of the bodily gesture, which we have seen in so many earlier works, reaches an extreme. In this regard, the work should be seen in relation to the experiments of his friend, the mime Van Osen (Fig. 3), with whom Schiele went to Krumau in 1910. Van Osen sought to develop a kind of language of gestural communication based on pseudoscientific researches in the Vienna Steinhof lunatic asylum, studying what he saw as the pathology of human movement and expression. Equally important in relation to this work are developments which took place in the theory and practice of contemporary dance which sought to articulate inner, emotional states through gestures and movements of the body. Like many expressionist artists, Schiele recognized the potential of such developments and, it seem clear, sought to extend the theme into pictorial form.

In the present work, the extraordinary gesture responds to the format of the paper on which the painting is done: the head is tilted to echo the top edge of the paper, the upper right arm the left edge of the paper. The result is a somewhat claustrophobic sense of compression suggesting an uncomfortable, contorted identity. Yet at the same time the earthy colours and the warm-looking shirt, jerkin and what appears to be a tie suggest a rather more stable sense of self than earlier, nude self-portraits in which such comforts were completely denied.

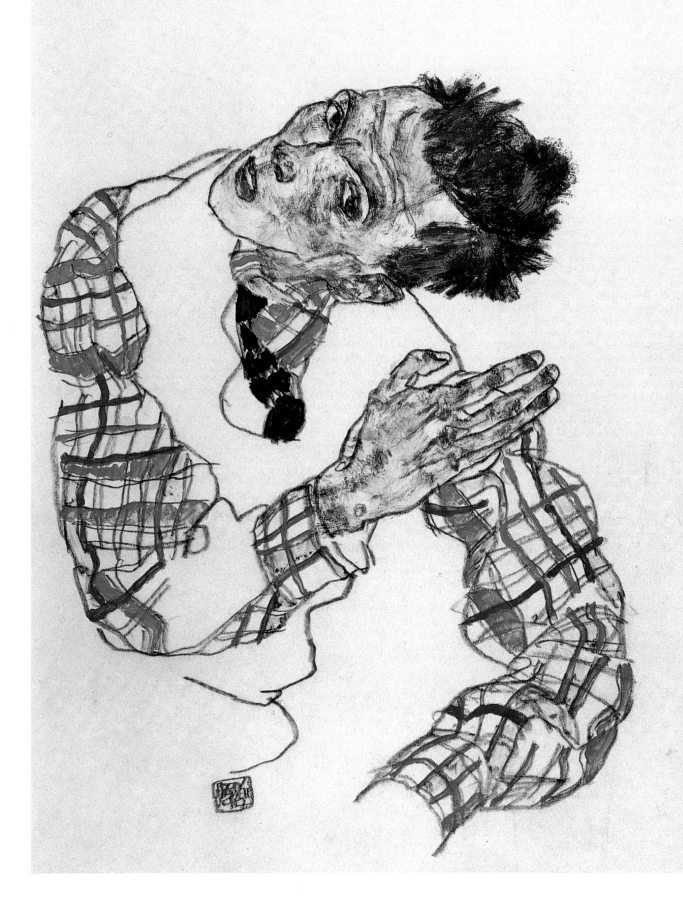

Portrait of an Old Man (Johannes Harms)

1916. Oil on canvas, 138.4 x 108 cm.
Solomon R. Guggenheim Museum, New York

During 1916, Schiele painted one portrait in oil. It is of his father-in-law, and was done in April. Comparison with the paintings of Russian prisoners made earlier in 1916 (Plate 38) shows a certain similarity in both the manner of representation – particularly the almost sculptural treatment of the coat, and the choice of earthy colours – and the sombre mood created. The portrait of Harms, however, focuses less on suffering as it attends to the subject's restrained, diffident character which so impressed Schiele. None the less, the old man looks exhausted as he leans on his left arm, his eyes obscured by the forehead which leans forward. Harms doesn't seem to sit comfortably in his seat; indeed he scarcely sits at all, as his fragile body, lost somewhere inside his oversized coat, slides from the chair. Within the following year, Edith's father would be dead. Appropriately, some of Schiele's works, including the earlier paintings of Lederer and Benesch (Plates 26 and 28), have been compared to those of the German Neue Sachlichkeit (New Objectivity) painters of the 1920s, who reacted against expressionist distortion. A further example of this new 'matter-of-factness' is the portrait of the industrialist Hugo Koller (Fig. 12). As with the portrait of Harms, we see an increased interest in the sitter's environment: in the case of Harms, the chair upon which he sits; in the case of Koller, not only the chair and the suggestion of a rug, but great stacks of books reflecting the subject's literary aspirations. In place of the isolation of the subject whose psyche was brought, through expressionist distortion of form and colour, to the surface, the artist now represents the sitter in an objective, far more sober fashion.

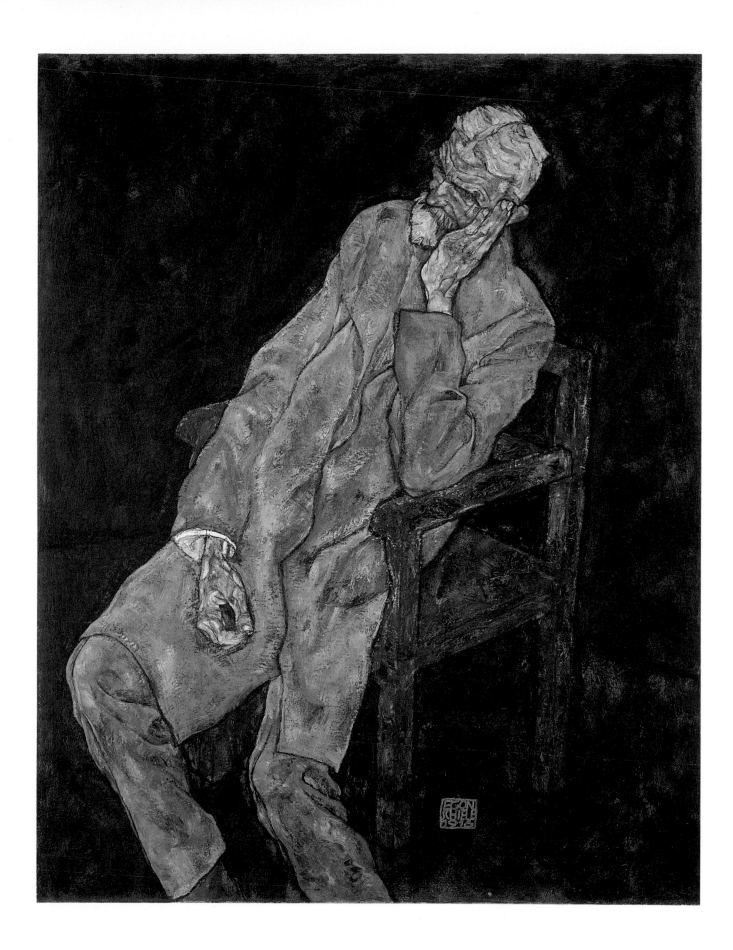

Four Trees

1917. Oil on canvas, 110.5 x 141 cm. Österreichische Galerie, Vienna

Four Trees differs in important ways from *A Tree in Late Autumn* and *Autumn Trees* (Plate 21 and Fig. 26). Most obvious is the regularity of the trees, evenly spaced, more or less the same distance from the bottom of the canvas. The only imbalance is in the number of leaves the trees have shed. Cutting through the vertical divisions created by the trees are a series of horizontal divisions created by the cloud lines; the slight undulations in these lines are then echoed and exaggerated in the curves of the land in the foreground and, in still more exaggerated form, in the mountains in the distance. In this way, the work becomes an extension of that geometricization of surface pattern which we saw in parts of certain earlier works such as *The Bridge* (Plate 27) and *Holy Family* (Plate 29). Here, however, the grid which emerges is almost invisible; it seems to form part of the nature at which we look, rather than being imposed upon it by the will of the artist. In *A Tree in Late Autumn*, Schiele represents the continuity he saw between things (a tree) and animate beings (man) by animating the tree; in the present work he constructs an (equally mystical) sense of continuity between things (the trees) and their (non-organic) environment. Whereas the earlier work might be considered something of a portrait of the tree, an object for Schiele's projected states of mind, *Four Trees* articulates a more disinterested account of the state of nature.

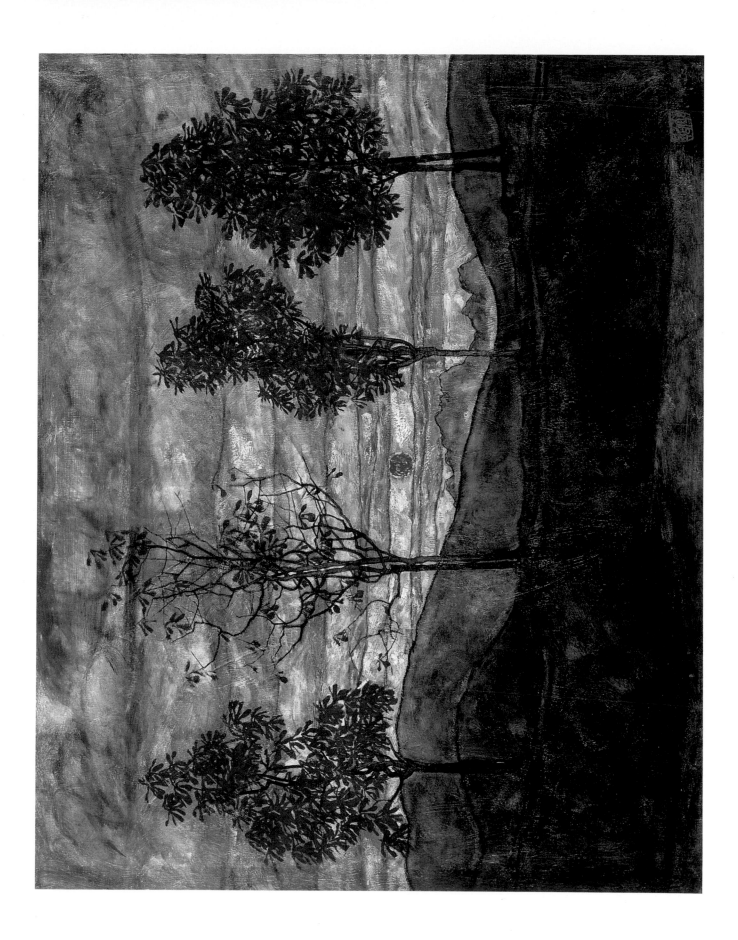

43

Embrace (Lovers II)

1917. Oil on canvas, 100 x 170.2 cm. Österreichische Galerie, Vienna

Compared with earlier key works which show embracing couples, such as *Embrace I* (Plate 36) and *Death and the Maiden* (Plate 34), *Embrace (Lovers II)* is different for its sense of harmony, a union of the two figures rather than conflict and tension. The female form holds the muscular (rather than emaciated) male form close to her ear, one hand laid gently on the left side of his face, while he leans forward holding her equally tightly to himself. Her sex is now covered by the familiar crumpled fabric upon which the figures lie; rather than genitals, it is now the long, elegant mass of hair which occupies the top right corner of the canvas and the feminine form of the body which signify her sex. The muscularity of his body, together with its more rugged surface and short hair, are conventional signifiers of the male. It is as if in this work – whether or not it can be read as a portrait of Schiele and his wife, Edith – the artist has finally surpassed those adolescent sexual anxieties which were so important to many earlier works, and now, from the secure perspective of a successful marriage, is able to present a scene of physical accord which is also one of emotional tranquillity.

This sense of emotional and physical harmony is accompanied by a formal harmony. The painting should in this respect be compared with Reclining Woman (Fig. 13), also of 1917, similar both compositionally (except that here it is just one rather than two figures which lie diagonally across the canvas) and in the manner of representation. No parts of the subjects' bodies are cut off by the edge of the canvas, and even the sheets upon which they lie are fully present.

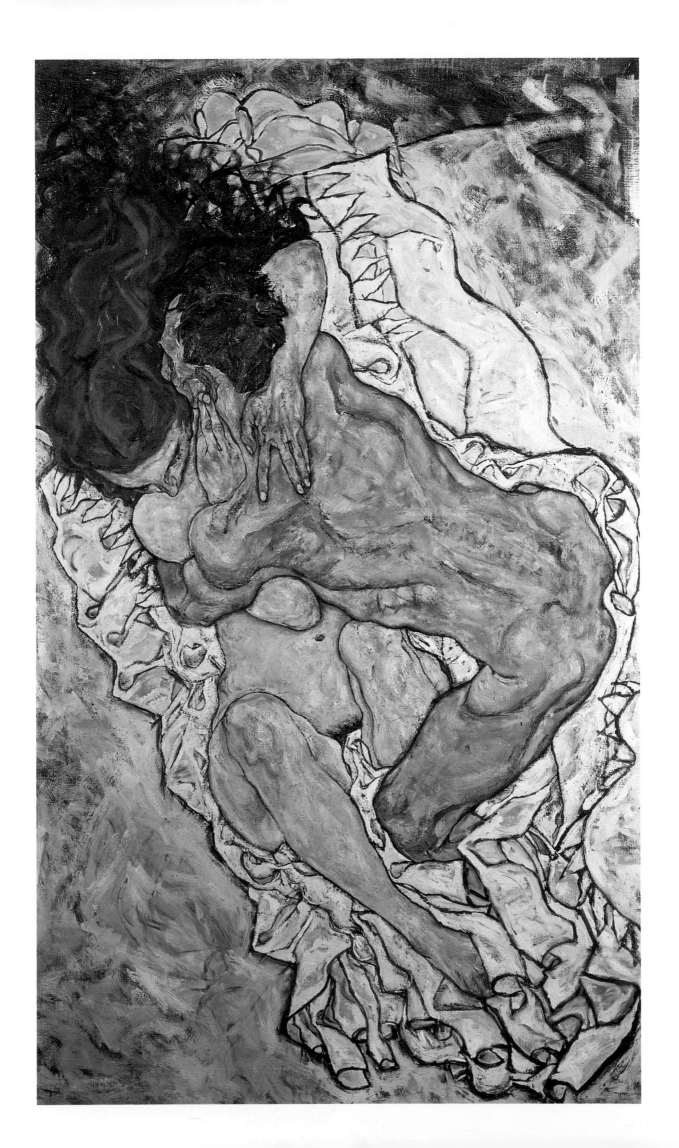

Portrait of the Artist's Wife, Seated

1918. Oil on canvas, 139.5 x 109.2 cm. Österreichische Galerie, Vienna

Although signed and dated 1918, the present portrait was painted in the early months of 1917. The work is similar to the portrait of Edith's father of the previous year (Plate 41) in respect of both works' sombre mood and presence of little else but the chair upon which neither sits comfortably. While Edith doesn't fall from the chair, she sits in a manner reminiscent of the portrait of Arthur Roessler (Plate 10), with her head turned uncomfortably away from her shoulders which themselves twist from the direction of her hips. Nevertheless, she sits secure in her chair, feet planted firmly on the ground, her eyes alert to what lies beyond her immediate environment. The sombre mood of the work we now see seems to have been at least partly the result of the changes the artist made to the work prior to signing it in 1918. In its original version Edith was wearing a brightly chequered skirt which was very fashionable in Vienna at the time, and we are told that Schiele overpainted the skirt with sombre colours at the request of Dr Franz Martin Haberditzl, who was buying the work for the state picture gallery (Staatsgalerie), and found it in its earlier form too decorative and 'proletarian'.

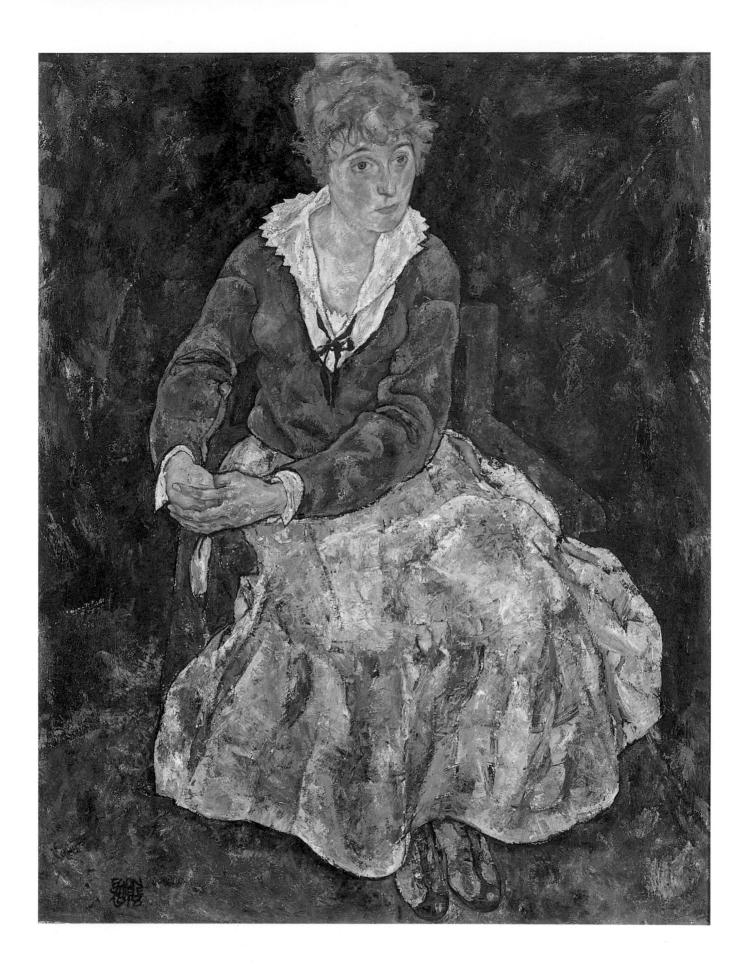

Portrait of the Painter Paris von Gütersloh

1918. Oil on canvas, 140.3 x 109.9 cm. The Minneapolis Institute of Arts

Having abandoned his training and career as an actor in 1909, Albert Paris von Gütersloh made his public debut as a painter at the Neukunstschau of that year. Associated with the circle which gathered about Klimt, Gütersloh was also a writer. He was in contact with Robert Musil, Hugo von Hofmannsthal and Hermann Bahr, and wrote one of the first published essays on the work of Schiele. He sat with Schiele on the committee which organized the 1918 Secession show, after which the two met frequently, presumably to do the present painting. Like Eduard Kosmack (Plate 11), the sitter is placed in the centre of the composition, gazing directly at the viewer. The manner of execution, however, is quite different. With the exception of Gütersloh's face, surfaces in the work are composed of what seems to be a chaos of brushstrokes contained and separated only by the almost mechanical dark lines which articulate the edges of forms and folds in fabric; without those lines, much of what is depicted would disappear into a flaming mass. The expressive intensity of this work harks back to Schiele's portraits of 1910; it is now, however, with the most painterly of means that the artist achieves this. Yet, at the same time there is something of his new 'sobriety' about the work. In particular, the sitter's face, with its accurately applied paint and relatively realistic appearance, insists upon being read as objective rather than expressive. Indeed, it is as if the significance of the work lies in precisely this contrast between what is composed and ordered and those ecstatic, almost chaotic parts of the work. The sense of angst in the sitter's face and gesture is accentuated by this uneasy relation.

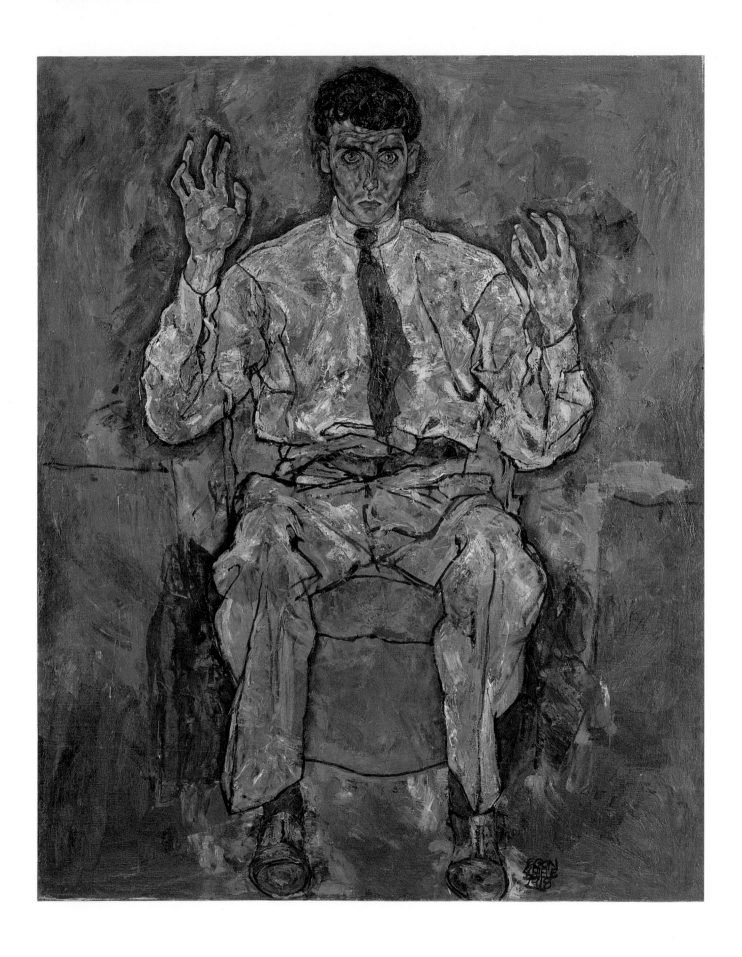

1918. Colour lithograph, 68 x 53.2 cm. Private collection

It was in the hope of re-creating a Viennese cultural community that Schiele wrote in 1917 of his wish to establish a Kunsthalle, 'a spiritual gathering place designed to offer poets, painters, sculptors, architects, and musicians the opportunity to interact'. To celebrate this idea of an artistic community, he painted *The Friends* (for which he had made plans as early as January 1917; Fig. 33), a large painting showing Schiele at the head of a long, L-shaped table, surrounded by his friends and close associates. In spite of support from key members of Vienna's avant-garde, the project never came to fruition and by mid-1917 was abandoned. The nearest Schiele came to any such collaborative event was the 49th Secession exhibition in 1918, which he was asked to organize. This enabled him to work with many of his old colleagues, and he used a scaled-down version of *The Friends* as the image on the advertising poster.

Marginalizing reference to the 'Last Supper' theme, Schiele replaced the plates of the painting with books in the poster. Perhaps more significant is the absence in the poster of the figure sitting closest to us at the bottom of the painting, whom the artist singled out for detailed treatment in a sketchbook study. The figure may be Klimt, who died in February 1918, and whose absence in the poster would therefore seem appropriate; in his place stands an empty chair and an open book. However, it has been suggested that in the painting the figure to the left of this place more closely resembles Klimt, while there is a striking similarity between the peculiar pose of the figure at the bottom of the painting and that in the *Portrait of the Painter Paris von Gütersloh* (Plate 45). In the absence of further evidence it is impossible to decide which account is the true one.

Fig. 33
The Friends
(Round Table), Large
1918. Oil on canvas,
100 x 119.5 cm.
Private collection

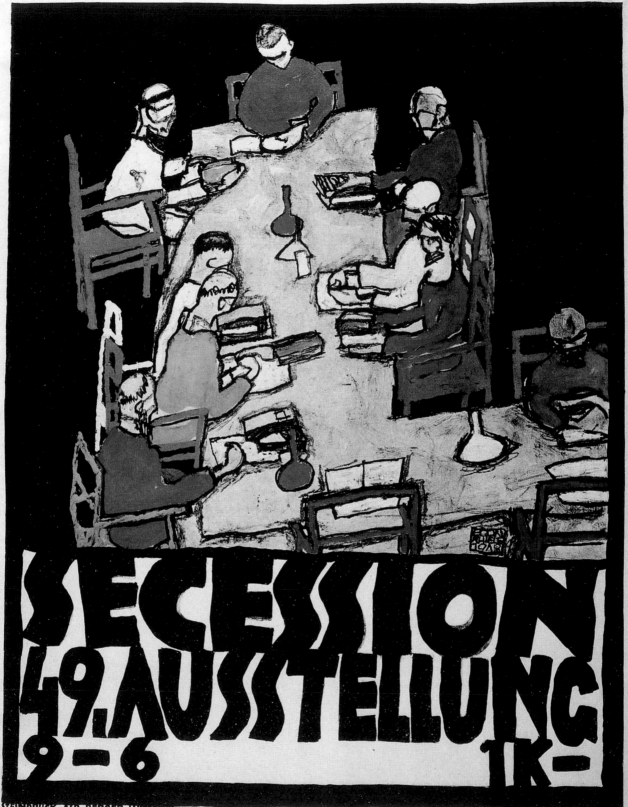

47 The Family (Squatting Couple)

1918. Oil on canvas, 152.5 x 162.5 cm. Österreichische Galerie, Vienna

The culmination of Schiele's new humanism and tranquillity is surely his seemingly unfinished *Family* of 1918, probably begun in 1917. Growing from the small child at the front, through what we take to be the mother to the father figure, Schiele himself, the composition suggests an inverted pyramid which, in spite of the inversion, is quite stable. The space of the male figure encloses that of the female, as that of the female encloses and protects the child. But before we assume this to be a simple picture of family harmony, we are forced to consider some contrary indications. First, while the male figure is the artist himself, the female is not his wife, though it has been argued that this woman stands for Edith. Second, according to Adele Harms, Edith's sister, the work was not originally intended to include Edith's expected child; rather, a bouquet of flowers lay at the woman's feet and was only later replaced by the infant. Third, Schiele never called the work *The Family*; when displayed at the 1918 Secession exhibition, it carried the title *Squatting Couple*, which, particularly when compared with the numerous Rodinesque works in the 'squatting' series produced at the same time, such as Fig. 34, would seem to lose the domestic connotation altogether. Coupled with the dark, almost menacing background, such details throw into question just how the work should be read. None the less, in spite of the various and complex stages through which the work passed, the compositional as well as apparent emotional harmony of the final product makes the domestic, pastoral reading seem most convincing.

Fig. 34
Squatting Women
1918. Oil and gouache
on canvas, 110 x 140 cm.
Rudolf Leopold
Collection, Vienna

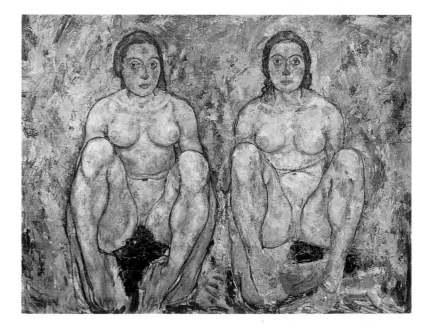

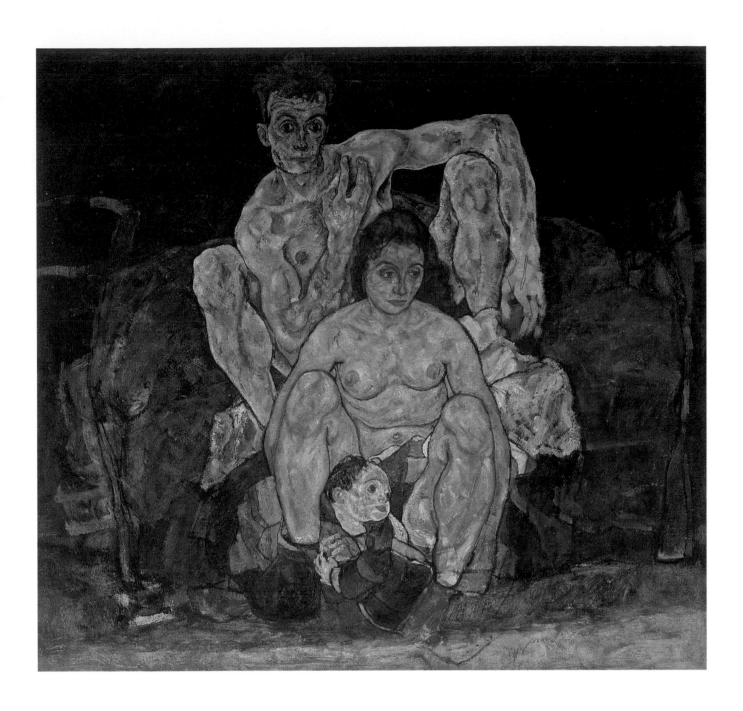

Ceramics (Peasant Jugs)

1918. Gouache, watercolour and charcoal on paper, 43.2 x 29.2 cm.
Private collection

During 1918, Schiele produced a series of four gouache paintings of groups of painted ceramic peasant jugs. The jugs are quite freely drawn with charcoal outlines, decorations and reflections, 'filled in' with various colours, giving them something of a cartoon-like quality. At one level we could interpret such works as indicative of the more domestic tone his works had adopted in the final years of his life. Yet there is still something of the portrait to the present work (albeit a group portrait), in which each form is apparently quite animated and – as had been the case with so many of his earlier portraits – set against a vacuous background. In addition to this it is significant that two of the jugs are broken, developing the theme of decay, perhaps even death, which we uncovered in relation not only to his portraits but also his representations of trees and other plant life. The presentation of the still life without a surface on which to stand, and the sense of unease this creates in the viewer, completes the picture: even when Schiele presents the most tranquil of subjects, the tensions and anxieties which informed his most expressive works are still present.

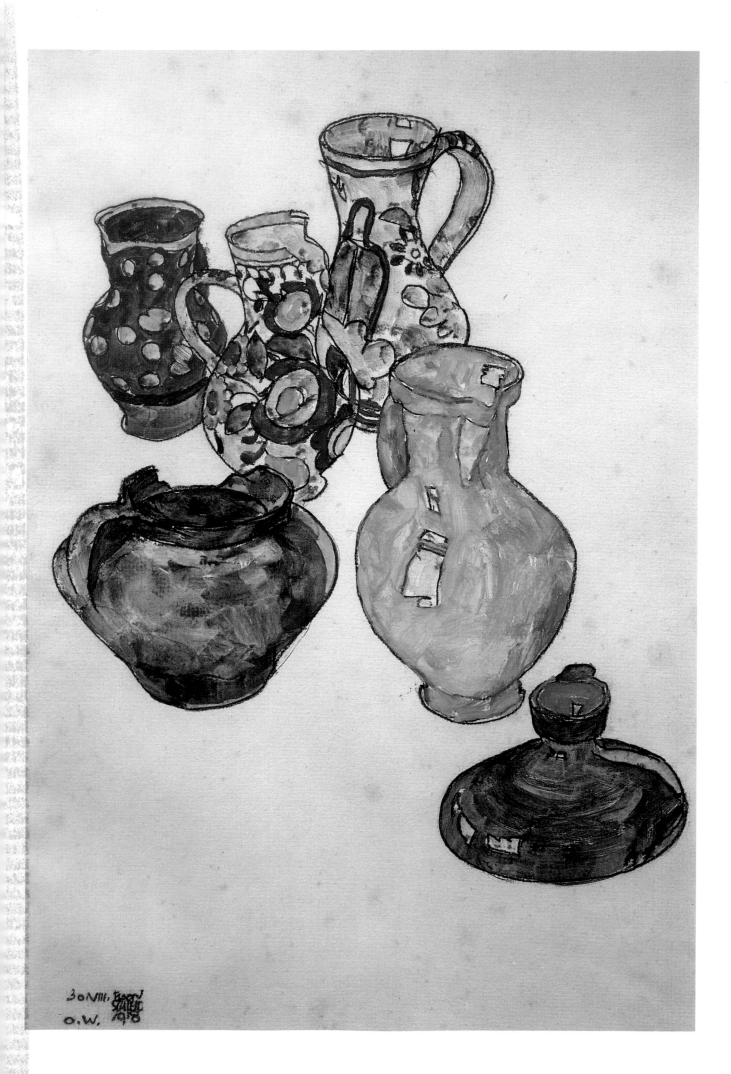

COLOUR LIBRARY

BONNARD
Julian Bell

PHAIDON

COLOUR LIBRARY

FIGARO

CUBISM
Philip Cooper

PHAIDON

COLOUR LIBRARY

DÜRER
Martin Bailey

PHAIDON

COLOUR LIBRARY

GAINSBOROUGH
Nicola Kalinsky

PHAIDON

COLOUR LIBRARY

IMPRESSIONISM
Mark Powell-Jones

PHAIDON

COLOUR LIBRARY

ITALIAN RENAISSANCE PAINTING
Sara Elliott

PHAIDON

COLOUR LIBRARY

DALI
Christopher Masters

PHAIDON

COLOUR LIBRARY

WHISTLER
Frances Spalding

PHAIDON

PHAIDON COLOUR LIBRARY

Titles in the series

SCHIELE